PHOTOGRAPHY AT THE MUSÉE D'ORSAY

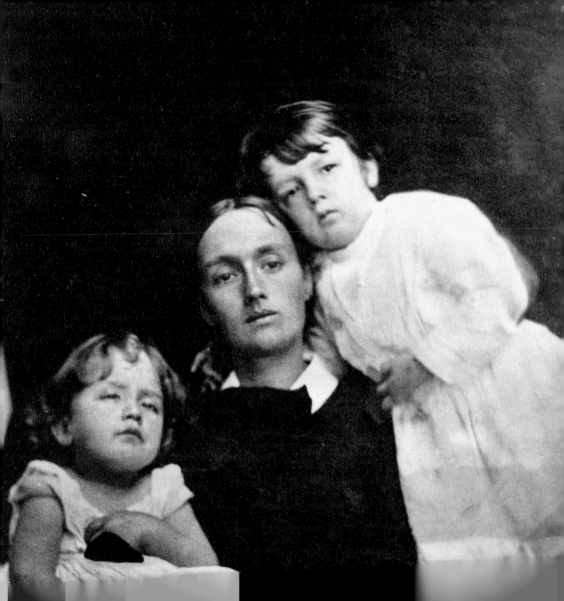

Françoise Heilbrun

# Figures
# and Portraits

**Musée d'Orsay**

This collection is directed by Serge Lemoine,
Chairman of the Musée d'Orsay.
All works reproduced in this volume belong
to the Musée d'Orsay's collection and
are kept in the museum.

This book has been conceived for the
exhibition *Figures et portraits* at Musée d'Orsay,
7th March – 4th June 2006.

The authors would especially like to thank
Doris Grunchec, Fabrice Golec, Laure de Margerie,
Pierre-Yves Laborde, Laurent Stanich,
Antoine Tasso and his team and the Clémecy team,
Bruno Dapaz, Mustapha Naggar.

www.musee-orsay.fr
info@5continentseditions.com

ISBN Musée d'Orsay : 2-905724-42-0
ISBN 5 Continents Editions : 88-7439-306-7

*Cover*
Charles Marville
*Charles Delahaye*
ca.1852

For the Musée d'Orsay

*Publication manager*
Annie Dufour

*Assisted by*
Virginie Berri

*Iconography and digitalization*
Patrice Schmidt and Alexis Brandt

For 5 Continents Editions

*Translation*
Isabel Ollivier

*Editorial Coordinator*
Laura Maggioni

*Design*
Lara Gariboldi

*Layout*
Virginia Maccagno

*Editing*
Timothy Stroud

*Colour Separation*
Eurofotolit, Cernusco sul Naviglio (Milan), Italy

*Printed in February 2006*
by Grafiche Milani, Segrate (Milan), Italy

Printed in Italy

# Table of Contents

Françoise Heilbrun

# Figures and Portraits

"The theory of photography can be learned in an hour; the first practical notions in a day. But I will tell you what cannot be learned: it is the sense of light, the artistic appreciation of the effects produced by various combinations of light. And what can be learned even less is the moral understanding of your subject, the swift feeling that puts you in communication with the model, and enables you to make, not an ordinary plastic reproduction, which is within reach of any laboratory workhorse, but the most familiar, sympathetic, innermost likeness. That is the psychological side of photography, and I do not think the word is too pretentious."

Félix Nadar, 1857

The pioneer photographers were faced with the problem of reproducing the human figure, and making portraits. At the beginning, they used a relatively slow, limited technique and modelled their work on the pictorial tradition. The Musée d'Orsay's collections give us an inevitably partial but significant idea of the way portraits developed in international photography between 1850 and 1915, in terms of both photographic practices and aesthetics. Without neglecting practices, it is particularly the aesthetics that interest us here, that is, the way photographers used light—"nature's paintbrush" as William Henry Fox Talbot (1800–77) so aptly put it—to bring out the sitter's personality.

## The Era of the Daguerreotype (1839–55)

Daguerre's invention, in 1839, sparked a demand in the middle classes for daguerreo type portraits instead of painted portraits. Studios opened in the main cities and travelling photographers worked in villages, fairs or near tourist sites. Family portraits, post-mortem portraits (a curious

form of iconography which developed fast in this time of high mortality), and ethnographic portraits soon became common, but they were produced in an empirical, non-standard manner. The use of the daguerreotype, a unique image which could not be copied without recourse to drawing and engraving, restricted the distribution of these portraits, with a few exceptions, to family and friends. They were hung on the wall, displayed on a piece of furniture, or kept in a case. In the United States, an entire industry sprang up to produce gilt repoussé metal frames and leather cases lined with satin or velvet. Some practitioners, whether professional portraitists, such as Albert Sands Southworth and Josiah Johnson Hawes, in Boston, or enthusiastic amateurs, like Baron Louis Adolphe Humbert de Molard, took great pains over aesthetics. Southworth went into partnership with the painter Hawes to photograph the intelligentsia of Boston, including many women (cat. 4 and Pho 1983 165). Their portraits of outstanding personalities were appreciated in their time, then forgotten, and rediscovered in the early twentieth century. They are striking for their intense expressions, vigorous attitudes and sculptural faces. The photographers' correspondence shows that they took pains to get to know the model before taking the photo. They were sensitive to the quality of the light, and were among the first to build studios lit by a skylight.

A full-length portrait, in photography as in painting, required skilful handling of light and great mastery of outline. This has been achieved in the portrait of *Robert and Clara Schumann* (cat. 1), which remains anonymous. It is an image of a couple united by music and absorbed in each other, rather than two great artists posing for eternity. The exquisite delicacy of each detail (down to the reflection of Clara's hand on the piano) brings them close to us, whereas the composition holds them at a distance. The precision of the daguerreotype, which gives models an undeniable presence, has lost none of its fascination today.

Humbert de Molard was not bound by any professional constraints and in the portraits of Louis Dodier, his steward and favourite model, he combined several genres, as he was wont to do. In this very intimate portrait, the close-up viewpoint, the smile and arresting gaze show

his attempt to catch a fleeting instant (cat. 5). De Molard photographed the same Dodier as a prisoner in his cell (Pho 1988 4). The scene is picturesque rather than heroic, but the portrait of the steward with his tense handsome face and masterly silhouette is superb.

The early photographic portraits of Victor Hugo (1802–85), taken by his son who had followed him into exile in Jersey, were not intended to be merely private documents: from the outset, as he told his publisher Jules Hetzel (1814–86), Hugo meant to use them as a means of propaganda, to break out of his isolation. He set up a family workshop, and it was there that a new image of the poet was developed (cat. 3), inspired by that of Chateaubriand. The enterprise was helped by the use of a glass negative, a process better suited to wide circulation, and Charles Hugo was sent to learn the technique from Edmond Bacot (1814–75), a Norman photographer and loyal Republican.

Daguerreotypists added colour and relief by hand or stereoscopy to make their portraits more attractive. Alexis Gouin, a miniaturist who had studied under Girodet (1767–1824) and Jean-Baptiste Regnault (1754–1829), started making daguerreotypes and soon became famous in both fields. He is attributed with this close-up portrait of Alexandre Dumas (1824–95) (cat. 2), which accentuates the writer's vitality, loquaciousness and sartorial elegance.

## The Calotype (1841–55)

In 1835, William Henry Fox Talbot started working on a photographic process using paper, which he perfected six years later; the use of a paper negative meant that several copies could be made of the image. The patent that he filed restricted its use in England but it was introduced to Scotland by Sir David Brewster (1781–1868). The artist David Octavius Hill, in partnership with the chemist Robert Adamson, used the technique to make portraits of Edinburgh society. The

artist originally intended to use his photographs as sketches for a large painting that he was preparing on the schism of the Scottish Church, but the two partners soon became interested in photography for its own sake. Their models—painters, sculptors, scholars, notables or ordinary fisherman from Newhaven (Pho 1980 264 and Pho 1983 165 131)—photographed in full sunlight, have the sweeping natural gestures found in paintings by Raeburn (1756–1823). Hill and Adamson turned the defects of the paper negative, which blurred outlines, to aesthetic advantage, modelling their subjects with blocks of light and shade. Their portraits, often compared to Rembrandt's (1606–69) prints, were highly appreciated in British and French artistic circles. At the turn of the nineteenth century, they were used as models by English and American Pictorialists (cat. 9). Hill and Adamson were just as inspired when they photographed children (cat. 8 and 9). Talbot had come to Paris in 1843 to promote his process and met Victor Regnault there (1810–78) but it was not until 1847 that the process was officially introduced into France. There it was transformed by Louis Désiré Blanquart-Évrard (1800–72), the Gutenberg of photography and an industrialist who opened France's first photographic print shop at Loos-lès-Lille in 1851.

Among the amateur photographers whose work was published by Blanquart-Évrard, there was the great scholar Victor Regnault and his friend Louis Robert who succeeded him at the head of the Sèvres porcelain factory. Both excelled in intimate portraits. Robert's photographs do not have the inner quality apparent in Regnault's work, but he portrayed members of his family with vivacity, grace and naturalness (cat. 13) and made effective use of light and shade (cat. 12). Henri Le Secq and Charles Nègre had met in the studio of the painter Paul Delaroche (1797–1856). They lived in the same district and often took photographs together, with a preference for medieval architecture. They had fun taking photographs of each other on the northern gallery of Notre-Dame Cathedral, where work was in progress at the time. Nègre's portrait of Le Secq (1818–82) is brilliantly composed and offers such a variety of interpretations that it has served as

a model for painters, photographers and caricaturists from the nineteenth century to the present day (cat. 17). Nègre paid tribute to his friend as an antique dealer and collector. In another photograph, Le Secq, still dressed in top hat and tails, appears in an improvised scene with a genuine organ grinder in the courtyard of 21, quai de Bourbon where Nègre had his studio (cat. 16). The portraits of Charles Delahaye by Charles Marville, who also worked with Blanquart-Évrard, are more experimental, with tight shots that were quite unusual for the time (cat. 18 and 19).

## The Era of the Glass Negative or the Flowering of Photographic Portraits (1854–60)

Frederick Scott Archer's invention in 1851 of a process using wet collodion on a glass plate was to have a decisive impact on portraiture, which developed into several separate genres. Apart from permitting multiple prints, the new process shortened exposure time to one second, and the high transparency of the glass and the emulsion gave a very precise line. Studios sprang up everywhere. In the same year heliographic companies were formed, first in France then in Great Britain, and their magazines and exhibitions helped distribute the photographs and develop critical thinking.

### Portraits of Celebrities

Nadar was the first to apply the theories about portrait photography expounded by Francis Wey in the magazine *La Lumière*, in 1851, particularly on the use of lighting to bring the face alive. Félix Tournachon, called Nadar, was a protégé of Charles Philipon (1800–62), who was the tutelary figure of political caricature, giving work to Daumier, Grandville and Gavarni, and the founder of *La Caricature* and *Charivari*. Nadar had already produced his outsize lithograph *Panthéon Nadar*, caricaturing the Parisian literary milieu. No doubt prompted by the publication of Théophile

Silvestre's *Histoire des artistes vivants*, he turned to photography and, about 1855, developed a type of portrait using his bohemian artist and writer friends as models, in the garden of his house in rue Saint-Lazare. His familiarity with caricature made him sensitive to ways of reproducing facial expressions, which were brilliantly demonstrated in photography in the plates of *Mécanisme de la physionomie humaine* executed by his brother Adrien Tournachon, under the supervision of Dr Armand Duchenne de Boulogne (1806–75), a great neurologist who had used photography to illustrate his research into the electrical stimulation of muscles. This example no doubt made him decide—again with his brother, who never managed to do anything by himself—to produce the series of photographs of *Pierrot* (cat. 20 and 21) played by Charles Deburau, a popular figure in the Théâtre des Funambules. The series is a remarkable study of gesture and movement and was hugely popular at the Universal Exhibition of Paris in 1855. Nadar had also closely studied Van Dyck (1599–1641), which can be seen in the way he uses modern costume to express character: Théophile Gautier's unbuttoned shirt (cat. 24), and Gustave Doré's scarf (cat. 25). He goes right to the heart of things, and even today, the observer is arrested by the gaze of Baudelaire (cat. 23), Théophile Gautier (cat. 24), Chenavard (cat. 22) or Maria, a West Indian model (cat. 26 and 27), whose grave expression contrasts with the fleshly splendour of her naked breast. Such an ambitious concept of portraiture could not compete on the market because it required a great deal of time and care. Later, aided by his wife, Nadar directed his various studios in a commercial spirit, although he still produced a few masterpieces when he was particularly interested by the model (Sarah Bernhardt, Pho 1983 165 131, or George Sand, Pho 1991 2 135). His first prints on richly textured salted paper were also standardised, when they were not painted, as was customary.

Pierre Étienne Carjat, a friend from Nadar's bohemian days, led a similar career; as talented as Nadar, he, too, tried to bring out the psychology of the model in his portraits (cat. 31). The sculptor Antoine-Samuel Adam-Salomon opened a studio aimed at the intellectual and artistic elite. But when we compare his elegant portraits of Liszt (cat. 29) and the composer's mistress

Countess Marie d'Agoult (cat. 28) with Nadar's portraits, we see that Adam-Salomon sacrificed naturalness to a virtuoso but conventional interpretation of the devices used by Van Dyck.

The shots taken of Victor Hugo by his son Charles are staged in a much more original way. Hugo is inseparable from the landscape, which plays a dual role, materialising the poet's symbiosis with nature (cat. 10) and the political commitment of the outcast, taunting the Emperor Napoleon III from the top of his rock (cat. 11). These photographs were never published but, despite censorship, were widely distributed among his family and friends.

Portraits of actors, artists and writers found a ready market. Jules Janin's book on Rachel, illustrated by photographs by Henri de La Blanchère, is an interesting exercise in iconography because the actress is shown in her main roles, dressed in classical costumes. The book was designed to promote classical tragedy, Rachel being a remarkable tragedienne, in the style of the actor Talma (cat. 14). Before setting off on a tour of Russia, Rachel had asked Charles Nègre to make a portrait of her, for her family and friends and no doubt her future admirers. It is remarkable for its intensity and the simple setting which does not trouble with proprieties (cat. 15).

Julia Margaret Cameron lived in the midst of a loyal circle of scholars, writers and artists. Making her debut in photography at the age of fifty, she decided to create her own gallery of outstanding people, which she sold through Colnaghi, a famous gallery and publishing house founded in London in the late eighteenth century. She held successful exhibitions of her work in London, Berlin and Paris. Although nourished by the pictorial models of the Italian Renaissance revered by the artists, collectors and museum directors she knew (Watts, Lord Overstone, Lord Elcho, Henri Cole), Cameron nonetheless respected the specificity of photography. She was very innovative, with close-up shots and a deliberate soft focus that anticipated movie photography. As she explained in a letter to Sir John Herschel (1792–1871), one of the most remarkable scientists of his time and one of the first to take an interest in the

sensitisation of silver salts by light, the source of chemical photography, she wanted to educate the public and make people understand that a portrait should have "roundness and full modelling", in other words, it should be something other than a "flat map of facial features" (cat. 34 and 35). She had considerable impact. Strangely enough, Cameron did not include herself in her pantheon, and although her female portraits, such as those of her niece Julia Jackson (cat. 32), occasionally express the radiant personality of the model, she mainly expected women to be young and beautiful and readily used them for allegorical studies or to illustrate poems (cat. 33).

*Society Portraits*
Eugène Disdéri, a brilliant businessman, filed a patent in 1854 which gave him sole rights over portrait cards: several poses on a single plate were printed on small cards. They were modestly priced and were intended to be used as visiting cards. The invention was immensely popular, turning portrait photography into an industry, and fierce competition sprang up among the studios. Each family had its albums in which famous people and royal figures were pasted alongside members of the family. Disdéri's portraits (cat. 44 and 45) are invaluable as a study of social behaviour, but relatively poor artistically. They capture only the outward appearance of the models, details of physical likeness and class, as conveyed by conventional attitudes and costumes, and no great effort was made to use light to enhance the whole. This practice, in which Disdéri admittedly excelled, was not unlike one of the uses of the daguerreotype and helps explain Baudelaire's anger at the 1859 salon and the contempt in which many artists held photography.
The portraits of Micmac Indians made in Newfoundland in 1859 by the naval photographer, Miot, perhaps at the request of Arthur de Gobineau, are, on the contrary, a moving testimony to the decadence of a "princely race", which had fallen on hard times (Pho 1987 25 2 and 3).

Just as moving is a portrait of a madwoman, (gift, with usufruct, of Mrs Suzanne Winsberg, Pho 1998 6) which was taken for scientific purposes by Dr Hugh Diamond, the director of the Surrey county asylum and a member of the Photographic Society.

*Intimate Portraits*

Intimate portraits by amateur photographers take us backstage and give a richer view of society. Olympe Aguado, who frequented the imperial court, recorded the surroundings (cat. 40) and entertainments of his class (cat. 41) with an insider's ease. Lady Hawarden, whose talent was appreciated by Lewis Carroll, asked her daughters to mime for her the coquetry and languor of teenage girls (cat. 38); and Lady Matheson took her inspiration from Van Dyck's mythological portraits, enveloping her young nieces (cat. 46 and 47) in billowing drapery. Jean-Baptiste Frénet (cat. 39) and the artists at the Sèvres porcelain factory (cat. 42 and 43), in the photographs they made of their close circle, have left us a valuable testimony about the everyday attitudes and typical gestures that someone like Degas sought in vain in the commercial photography of the time and tried to express in his painting. Lewis Carroll learned the basics of photography in 1856 from a colleague at Oxford, Reginald Southey, and made a point of mastering its technical side, even building himself a glass-roofed studio in 1868. Adopting the contemporary taste for *tableaux vivants*, he gave the title *Penitence* to a photograph of a sulky Xie Kitchin in her nightgown (cat. 48). But his correspondence and diary reveal that, for the author of *Alice in Wonderland*, photography was something more, serving as a means of expressing his special relationship with childhood, of which he was both an observer and an actor. This very personal use of photography as a means of self-expression was full of promise for the future. When the Countess of Castiglione, who soon became the mistress of Emperor Napoleon III, called on the photographer Louis Pearson to execute what turned out to be an on-going self-portrait lasting until the end of her life, she at first

sought to glorify her own beauty, which dazzled all her contemporaries. But there was an element of exorcism in her project, as Pierre Aparaxine has rightly pointed out (see Bibliography, p. 31), which betrayed the panic and melancholy of this capricious woman, who was so richly endowed and yet barely able to take advantage of her assets. It is, therefore, not surprising that the very audacious scenes she staged (cat. 53) do not always show her at her best. In her last years, when she had become frankly ugly, she continued, with poignant stubbornness, to have herself photographed draped in the trappings of her past splendour (cat. 52).

If photography had not become extremely simple in the late nineteenth century, neither Zola nor Degas would have found time to use it—Zola for his tender scrutiny of the face of his daughter Denise (cat. 50 and 51) and Degas to produce theatrical scenes of his friends at home (cat. 56 and 57). *Portrait au miroir d'Henry Lerolle et de ses deux filles, Yvonne et Christine* (cat. 57), a recently discovered print, plunges us into the world of the Symbolists whom Degas mixed with in the Lerolles' salon. For Zola, photography was a way of deepening his vision, for Degas, it meant experimenting with artistic research in a new medium.

## Portraiture at the Turn of the Century

About 1890, easy-to-handle, moderately priced instant cameras came on the market, preparing the way for mass photography. Paradoxically this opened a boundless field to subjectivity. Portable cameras led to unusual viewpoints and extended the previously strict frameworks of portraiture. This can be seen in the intimate portraits by Henri Rivière (1864–1951) or Pierre Bonnard (1867–1947), for example, and to a lesser degree in the studio portraits of actresses and dancers made by Émile and Léopold Reutlinger, among others, for a growing public of enthusiasts. A whimsical mood prevails, probably borrowed from poster art. There is a desire

to embellish the models with makeup, plunging necklines and fetching poses (cat. 54 and 55). This is one of the earliest manifestations of the star system. The elegant, cosmopolitan Adolphe de Meyer, one of the masters of Pictorialism, who settled in the United States in 1913 and was soon taken on by Condé Nast, the director of *Vogue* and *Vanity Fair*, carried this type of portrait to the height of perfection, using artificial lighting, mirrors and high-quality prints to add sheen to fabrics and flesh (cat. 59).

Edward Steichen, a member of Photo Secession founded by Alfred Stieglitz, was strongly influenced by Rodin's work and produced masterly portraits of artists in the early twentieth century. His idea of making the sculptor Bartholomé pose under one of his own sculptures, which looms out of the background and seems to watch over its creator, is simply magnificent (cat. 58). The series that Stieglitz executed nearly fifteen years later with the artists that he promoted in his gallery, ranging from Mardsen Hartley to Picabia, is in a completely different spirit—direct, modern, and stripped of all hint of symbolism. Man Ray (1890–1976) was still a beginner when Stieglitz decided to make an impromptu portrait of him in Gallery 291 where he had called in to see his prestigious elder (cat. 62). There is an almost Expressionist tension in the lack of symmetry of the layout and the use of the facial features (eyebrows, shock of hair) which links it to the Viennese Secession. Paul Strand also escaped from the closed world of Pictorialism. He went out into the world and photographed colourful characters in the streets of New York. He then used a small "detective" camera which enabled him to take close-up photographs of his models unawares. Hence their monumental aspect and the violence which emanates from them. Although, like de Meyer photographing ugly mugs in the slums of London, Strand sometimes seems to be looking for a picturesque quality (cat. 60), he obviously felt deep fellowship with ordinary people (cat. 61). He looked at them in an attentive way that was never to leave him. The multiplication of social reporting since the end of the nineteenth century has, incidentally, given the most disadvantaged section of the population access to portraiture at last.

Joëlle Bolloch

Entries

**1. Anonymous**, *Robert et Clara Schumann* [Robert and Clara Schumann], ca. 1850. Daguerreotype, 10.8 x 8.1 cm. Gift of Mrs Phyllis Lambert, in memory of her sister Minda Bronfman, Baroness of Gunzburg.
PHO 1986 90
"I never feel as good and as happy as when I am with him. He doesn't need to talk at all. I love him so much when he is just thinking that I would like to be able to listen to each idea", the young pianist and composer Clara Wieck (1819–96) wrote in her diary a few months before marrying Robert Schumann (1810–56) in September 1840.

**2. Alexis Louis Charles Gouin** (?, 1799 – ?, 1855), attributed to, *Portrait d'Alexandre Dumas* [Portrait of Alexandre Dumas], ca. 1851. One of the views of a stereoscopic daguerreotype with coloured highlights, 6.7 x 6 cm each. Purchased with the aid of the National Photography Commission.
PHO 2001 8
Alexis Gouin was a student of Girodet, and first saw stereoscopic daguerreotypes at the Great Exhibition in London in 1851. These photographs were made to be seen through a device which gave the impression of three dimensions. Gouin used the process to make portraits of Alexandre Dumas, the sculptor James Pradier (1792–1852) and his sister Louise, who belonged to his circle of friends.

**3. François-Victor Hugo** (Paris, 1828–73), *Victor Hugo accoudé à une barrière, devant la façade arrière de Marine-Terrace* [Victor Hugo, Leaning on a Gate, with the Back Wall of Marine Terrace in the Background], 1853. Daguerreotype, 6.7 x 5.2 cm.
PHO 1985 80 1
This portrait is dedicated "To Victor Schœlcher, my intrepid colleague and friend, my companion in struggle, my brother in exile, Victor Hugo. Jersey, 24 March 1853". Both opponents of Napoleon III, they met in London after leaving Paris following the coup d'état of 2 December 1851.

**4. Southworth & Hawes** (Albert Sands Southworth, West Fairlee, Vermont, 1811 – Boston, Massachusetts, 1894, and Josiah Johnson Hawes, Wayland, Massachusetts, 1808 – Boston, Massachusetts, 1901), *Sarah Jane Clarke*, ca. 1850. Daguerreotype, 22 x 16.5 cm. Gift of the Kodak-Pathé Foundation.
PHO 1983 165 395
A militant feminist and abolitionist, Sarah Jane Clarke wrote for many American magazines under the pen name of Grace Greenwood, and was a European correspondent for *The New York Times*. Southworth and Hawes made at least three other portraits of Sarah Jane Clark on the same day as this one, and another, several years before.

**5. Louis Adolphe Humbert de Molard** (Paris, 1800–74), *Portrait de Louis Dodier, la joue appuyée sur la main* [Portrait of Louis Dodier, Resting his Cheek on his Hand], ca. 1845. Daguerreotype, 8.5 x 7 cm.
PHO 2005 5 2
Louis Dodier, the steward of the château d'Argentelle, Humbert de Molard's family home, posed for the photographer on several occasions.

He often appears in group compositions and sometimes, as in this daguerreotype recently purchased by the Musée d'Orsay, stands on his own.

**Anonymous**

**6.** *Portrait après décès* [Post-mortem Portrait], ca. 1860. Coloured ambrotype (collodion positive), 6.8 x 5.4 cm. Gift of the Kodak-Pathé Foundation.
PHO 1983 165 456

**7.** *Famille au chevet d'une jeune femme décédée* [Family at the Deathbed of a Young Woman], 1840–50. Daguerreotype, 9.5 x 7 cm.
PHO 1986 60

From the early days of photography, post-mortem portraits were very popular because they allowed family and friends to keep an image of the deceased person's features, something which had previously been possible only through very costly painted portraits or death masks. It was often the first and only portrait of the person who had died, so it was common to photograph the face close-up on the pillow as if sleeping, or to open the eyes to maintain the illusion of life.

**David Octavius Hill** (Perth, Scotland, 1802 – Newington Lodge, Edinburgh, 1870) and **Robert Adamson** (St Andrew's, Scotland, 1821–48)

**8.** *Sophia Finlay and Harriet Farnie, with 'Brownie'*, also called *The Sleepers*, 1845. Salted paper print from a paper negative, 19.5 x 15.2 cm.
PHO 1987 19

**9.** *The Finlay Children*, also called *The Minnow Pool*, 1909. Photoengraving from an original negative dated 1846, 21 x 16 cm. *Camera Work*, no. 28, pl. I, October 1909. Gift of Minda de Gunzburg through the Friends of the Musée d'Orsay.
PHO 1981 28 27
This is a picture of Charles Finlay's three children, Sophia, John Hope and Arthur. Hill and Adamson's calotypes were greatly admired by the Pictorialists, and combined a keen sense of composition with skilful use of light.

**Charles Hugo** (Paris, 1826 – Bordeaux, France, 1871)

**10.** *Victor Hugo dans le rocher des Proscrits* [Victor Hugo on the Outcasts' Rock], ca. 1853. Salted paper print, 10.3 x 6.3 cm. Gift of Marie-Thérèse and André Jammes.
PHO 1984 86 43

**11.** *Victor Hugo sur le rocher des Proscrits* [Victor Hugo on the Outcasts' Rock], ca. 1853. Salted paper print, 17 x 17 cm.
PHO 1986 123 162

While he was in exile in Jersey, Victor Hugo was often photographed by Auguste Vacquerie or, as in these two prints, by his son Charles. These portraits, along with photographs of the landscape of Jersey and nearby islands, were intended to illustrate a book which was never published.

**Louis Robert** (Paris, 1810 – Sèvres, France, 1882)

**12.** *La fille du photographe, Caroline, avec son époux, le peintre Émile Van Marcke* [The Photographer's Daughter, Caroline, with her Husband, the Painter Émile Van Marcke], ca. 1852. Salted paper print from a paper negative, 22.2 x 13.4 cm. Purchased by the National Photography Commission for the Musée d'Orsay.
PHO 1990 19

**13.** *La fille du photographe, Caroline, avec son époux, le peintre Émile Van Marcke, et Églée Marie Robert, dans le jardin de la manufacture de Sèvres* [The Photographer's Daughter, Caroline, with her Husband, the Painter Émile Van Marcke, and Églée Marie Robert, in the Garden of the Sèvres Porcelain Factory], ca. 1852. Salted paper print from a paper negative, glued on paper, 23.7 x 17.8 cm.
PHO 1984 98 50

The people in these photographs are all well known to the photographer. They seem particularly lively considering the prints were made before the invention of instant photography. To obtain this effect, despite the long exposure time, Louis Robert has made clever use of light and shade and dissymmetry.

**14. Henri de La Blanchère** (La Flèche, France, 1821 – Paris, 1880), *Rachel dans le rôle de « Camille »* [Rachel in the Role of *Camille*], published in 1859. Salted paper print, retouched, 19 x 14 cm. Gift of the Kodak-Pathé Foundation.
PHO 1983 165 156 3

To illustrate Jules Janin's book *Rachel et la tragédie*, La Blanchère took 10 photographs of Rachel (1821–58) in some of her greatest roles. The actress started her career in March 1838 at the Théâtre français as Camille in *Horace* by Pierre Corneille.

**Charles Nègre** (Grasse, France, 1820–80)

**15.** *Portrait de Rachel à Auteuil* [Portrait of Rachel at Auteuil], 1853. Salted paper print from a collodion-on-glass negative, 18.8 x 15 cm.
PHO 2002 1 1
Introduced to Rachel by the painter Charles Chaplin (1825–91), Charles Nègre was commissioned by the actress, who was about to set off on a year's tour of Russia, to make a series of portraits that she wished to use for advertising purposes or as gifts for her admirers.

**16.** *Henri Le Secq et une petite fille faisant l'aumône au joueur d'orgue* [Henri Le Secq and a Little Girl Giving Alms to an Organ Grinder], before May 1853. Dry waxed paper negative, 16.5 x 21.5 cm.
PHO 1999 2
This scene belongs to a set of prints all on the same theme. It brings together an emblematic Paris street performer—an organ grinder—and one of Nègre's friends, the photographer Henri Le Secq, who taught him the calotype technique.

**17.** *Le Stryge* [The Harpy], 1853. Salted paper print from a dry waxed paper negative, 32.5 x 23 cm.
PHO 2002 1 2

By getting Henri Le Secq to pose on the gallery of the north tower of Notre-Dame, Nègre has chosen a setting which evokes both his friend's taste for Gothic architecture, which he had photographed several times, and his love for Paris of which he was one of the first photographers.

**Charles Marville** (Paris, 1816 – ca. 1879)

**18.** *Charles Delahaye*, ca. 1852. Salted paper print from a paper negative, 21.8 x 18.8 cm.
PHO 1998 5 4

**19.** *Charles Delahaye debout sur un balcon, rue Saint-Dominique (?)* [Charles Delahaye Standing on a Balcony, rue Saint-Dominique (?)], ca. 1852. Albumen print, 20.6 x 12.1 cm.
PHO 1998 5 8

Charles Delahaye was probably Charles Marville's assistant in the 1850s. Taken in Marville's studio as a sideline to his usual work on architecture and landscapes, these prints were not intended to be exhibited or sold. The photographer was thus free to move away from the stilted poses common in photographs of the time.

**Félix Nadar** (Paris, 1820 – 1910) and **Adrien Tournachon** (Paris, 1825 – 1903)

**20.** *Pierrot au pot de médecine* [Pierrot with the Medicine Jar], ca. 1854. Salted paper print, 28.7 x 21.1 cm. Gift of Marie-Thérèse and André Jammes.
PHO 1991 1 8

**21.** *Pierrot souffrant* [Pierrot in Pain], ca. 1854. Salted paper print from a glass negative, 28 x 17.8 cm.
PHO 1986 73

The mime artist Charles Deburau, the son of the famous actor Jean-Gaspard Deburau, who breathed new life into the character of Pierrot, produced a wide range of facial expressions at the request of Félix Nadar and his brother Adrien Tournachon. Here Pierrot is in pain—perhaps from overeating—and is lifting the lid of a jar of jalap, a radical laxative made from the root of a Mexican plant. Some fifteen of these facial expressions were exhibited at the Universal Exhibition in Paris in 1855.

**Félix Nadar**

**22.** *Chenavard, peintre à l'Institut* [Chenavard, a Painter at the Institute], 1856. Salted paper print, 24.6 x 19 cm. Purchased with the aid of the Heritage Fund.
PHO 1991 2 78
Paul Chenavard (1807–95), a painter from Lyons, very impressed by his meeting with the philosopher Friedrich Hegel, planned a major decoration project *Palingénésie universelle* or *Philosophie de l'Histoire*. He had intended to paint it in the Pantheon to fulfil the commission he had received in 1848, but the monument reverted to a church in 1851 and then the project was dropped. Chenavard was keenly disappointed and stopped painting for a time but returned to the Salon in 1869 with *The Divine Comedy*, a large painting now in the Musée d'Orsay (inv. 20635).

**23.** *Portrait de Charles Baudelaire* [Portrait of Charles Baudelaire], ca. 1856. Salted paper print from a collodion-on-glass negative, 24 x 18 cm. Purchased with the aid of the Friends of the Musée d'Orsay.
PHO 1988 30
In 1865, Baudelaire (1821–67) wrote to his mother, Mrs Aupick, that he would like to have a portrait of her, but abhorred the fact that most photographers "consider a good image a picture in which all the warts, wrinkles, defects, and crude details of the face are clearly visible and highly accentuated" while what he wanted was "a true portrait, but with the *haziness* of a drawing".

**24.** *Théophile Gautier à la blouse blanche* [Théophile Gautier in a White Smock], ca. 1854. Salted paper print, 23.5 x 18.6 cm. Purchased with the aid of the Heritage Fund.
PHO 1991 2 74
Although sharing, or pretending to share, Balzac's worries about the new technique, Théophile Gautier (1811–72) and Gérard de Nerval "while both talking about ghosts, were the very first to pose in front of our lenses, with no fuss at all", Nadar remembered in *Quand j'étais photographe* (1900).

**25.** *Gustave Doré au drapé* [Gustave Doré Draped], ca. 1856. Salted paper print, 24.9 x 17.4 cm. Purchased with the aid of the Heritage Fund.
PHO 1991 2 4
From the age of fifteen, Gustave Doré (1833–83) contributed to the *Journal pour rire* directed by Charles Philipon. He made friends with Nadar, who made many portraits of the artist right up to the last one, on his deathbed.

**26–27.** *Maria l'Antillaise* [Maria, a West Indian Woman], ca. 1856. Salted paper prints from collodion-on-glass negatives, 25 x 19 cm.
PHO 1981 37 and PHO 1981 36
It was thought that this portrait was of Rose, a servant of the Nadar family. A portrait card deposited at the Bibliothèque impériale in 1862 has enabled the sitter to be identified as a model called Maria.

**Antoine-Samuel Adam-Salomon** (La Ferté-sous-Jouarre, France, 1811 – Paris, 1881)
Salted paper prints from collodion-on-glass negatives, 16 x 16.9 cm each.

**28.** *Marie d'Agoult*, (1805–76), ca. 1861.
PHO 1988 24

**29.** *Franz Liszt*, (1811–86), ca. 1861.
PHO 1988 23

"The photograph is the photographer. Since we've seen the marvellous portraits taken under the bright sunshine by Adam-Salomon, the sentimental statue maker, who is weary of painting, we no longer say it is a trade; it is an art; it is better than an art, it is a solar phenomenon in which the artist works with the sun" (Lamartine, *Cours familier de littérature*, interview 37, 1858).

**30. Pierre Petit** (Aups, France, 1832 – Paris, 1909), *Camille Corot*, ca. 1860. Albumen print from a collodion-on-glass negative, 28.8 x 22.2 cm.
PHO 1981 43
Pierre Petit, nicknamed "Hairy Collodion", took great care over this photograph of the landscapist

Camille Corot (1796–1875): the pose is carefully studied, the face appears to be illuminated by the white collar which separates it from the black suit, the eyes seem to be gazing into the distance, while the ghost of a smile gives the whole portrait a peaceful mood.

**31. Pierre Étienne Carjat** (Fareins, France, 1828 – Paris, 1906), *Eugène Delacroix*, ca. 1861. Albumen print from a collodion-on-glass negative, 25.4 x 18 cm. Gift of the Texbraun gallery.
PHO 1986 39 3
Eugène Delacroix posed at least twice for Carjat and seems to have preferred his photographs to that taken in 1852 by Nadar, whom he asked to destroy the negative and the prints, insisting "for heaven' s sake, out of friendship from me, don't keep any of the results of that moment".

**Julia Margaret Cameron** (Calcutta, India, 1815 – Kalutara, Sri Lanka, 1879)

**32.** *Madame Herbert Duckworth, mère de Virginia Woolf* [Mrs Herbert Duckworth, the Mother of Virginia Woolf], 1872. Carbon print, 39.8 x 25.5 cm. Gift of the Texbraun gallery.
PHO 1986 36
The photographer's niece was one of her favourite models. Julia Jackson (1846–95) first married a lawyer, Herbert Duckworth, then, after his death, Sir Leslie Stephen, with whom she had four children, two of whom became famous: Vanessa Bell and Virginia Woolf. In 1926, Virginia Woolf and Roger Fry signed the preface to a book on the work of Virginia's great aunt.

**33.** *Maud*, ca. 1875. Carbon print, 30 x 25 cm.
PHO 1984 44
Mary Hillier (1847–1936) was a domestic in Cameron's house between 1861 and 1875, when the photographer was living in Freshwater Bay on the Isle of Wight. This portrait was chosen to illustrate *Maud*, a poem by Alfred Tennyson (1855).

**34.** *Carlyle*. Photoengraving from an original negative dated 1867, 21.7 x 16 cm. *Camera Work*, no. 41, pl. I, January 1913. Gift of Minda de Gunzburg through the Friends of the Musée d'Orsay.
PHO 1981 32 1

**35.** *William Holman Hunt*, 1864. Albumen print from a collodion-on-glass negative, 23 x 18 cm.
PHO 1984 99
Some of Julia Margaret Cameron's friends accused her of lionising artists, meaning she courted their company merely to photograph them. She took photographs of the writer Thomas Carlyle (1795–1881) and the Pre-Raphaelite painter William Holman Hunt (1827–1910) in the salon held by her sister Sara in Little Holland House in Kensington, London.

**36. Charles Nègre**, *Trois enfants et un chien dans un parc* [Three Children and a Dog in a Park], ca. 1853. Albumen print from a collodion-on-glass negative, 12.2 x 16.9 cm.
PHO 1981 12
It is not clear who the children in this photograph are, though they are traditionally thought to be Rachel's. The actress had two children. The elder,

Alexandre, was the son of Alexandre Walewski, himself an illegitimate son of Napoleon; he was born in 1845 and would have been eight years old when the photograph was taken. The second, Gabriel, then aged five, was the son of Arthur Bertrand, whose own father was General Bertrand, one of Napoleon's last loyal followers.

**37. Julia Margaret Cameron**, *Group*, ca. 1870. Albumen print from a glass negative, 9 x 9 cm. Gift of the Friends of the Musée d'Orsay.
PHO 1984 19
The woman is Annie Chinery Cameron, the wife of the photographer's second son. The children have not been identified. Shortly after their wedding, Ewen Wrottesley Hay Cameron and his wife set off for Ceylon, where, true to the family tradition, they ran a coffee plantation.

**38. Lady Clementina Hawarden** (Glasgow, Scotland, 1822 – London, 1865), *Isabella Grace Maude se regardant dans un miroir* [Isabella Grace Maude Looking at Herself in a Mirror], 1861. Albumen print from a collodion-on-glass negative, 6.3 x 5.4 cm.
PHO 1983 85
The photographer converted into a studio one of the reception rooms in the house at 5 Princess Garden, London, where the family moved in 1859. She had her family and friends pose for her, especially the children she had by her marriage with Cornwallis Maude, the future Viscount Hawarden.

**39. Jean-Baptiste Frénet** (Lyons, France, 1814 – Charly, France, 1889), *Les Deux Sœurs* [The Two

Sisters], ca. 1855. Salted paper print from a paper negative, 23.5 x 17.7 cm.
PHO 2000 1
The sale in January 2000 of the contents of the photographic studio of Jean-Baptiste Frénet, previously known mainly for his paintings, revealed a great portraitist, and photographer who did not follow the aesthetic conventions applied by the professional studios.

**Olympe Aguado (Count)** (Paris, 1827 – Compiègne, France, 1894)

**40.** *Château de Sivry, vue intérieure d'un salon* [Château de Sivry, Interior of a Drawing Room], ca. 1856. Albumen print from a glass negative, 16.5 x 12.3 cm.
PHO 1995 4

**41.** *La Lecture* [Reading], ca. 1862. Albumen print from a collodion-on-glass negative, 14.5 x 19.2 cm.
PHO 1998 10

Both these prints can be considered as portraits not of an individual but of a social milieu. An amateur photographer, rich aristocrat, and son of a great collector, Aguado obviously enjoyed humorously depicting the interiors and manners of high society.

**Achille Bonnuit** (?, 1833 – ?, after 1899)

**42.** *Groupe de femmes* [A Group of Women], ca. 1870. Albumen print from a collodion-on-glass negative, 16 x 12 cm.
PHO 1984 70 55

**43.** *Le Repos* [Rest], ca. 1860. Albumen print from a collodion-on-glass negative, 11.4 x 8.8 cm.
PHO 1984 73 60

Achille Bonnuit's prints take us into the private life of the painters and decorators at the Sèvres porcelain factory where he worked alongside Louis Robert. Élisa Le Guay, herself a painter at the porcelain factory, perhaps helped him to stage his scenes.

**André-Adolphe-Eugène Disdéri** (Paris, 1819 – 89)
Albumen prints, each 20 x 23.3 cm.

**44.** *Marquise de Jalar en pied, en huit poses* [Marquise de Jalar, full-length, Eight Poses], 1860.
PHO 1995 9 38

**45.** *Princesse de Polignac, en huit poses* [Princesse de Polignac, Eight Poses], 1859.
PHO 1995 9 1

Disdéri made no attempt to bring out the personality of his model. He was chiefly interested in arranging folds and drapery, positioning the body and choosing props.

**Marie Jane Matheson (Lady)** (? – ?, 1882)

**46–47.** *Adelaïde et Elizabeth Denys enveloppées dans un châle* [Adelaide and Elizabeth Denys, Wrapped in a Shawl], ca. 1860. Albumen prints from glass negatives, each 16.8 x 21.6 cm.
PHO 1985 75 16 and PHO 1985 75 12
Thomas Sutton's comments about prints by Oscar Gustav Rejlander, a photographer whom Lady Matheson knew well, are relevant to these works: "You may find some wonderful young woman, and wrap her artfully in a blanket, […] and call her 'Summer', but it won't do, Mr Rejlander: the lady isn't Summer; there is strong evidence somewhere that she is Miss Jane Brown or Sophia Smith, and the drapery, a blanket, […]". Here, the very carnal presence of Lady Matheson's nieces is hard to ignore in what could be interpreted as an allegory of nature.

**Lewis Carroll (Charles Lutwidge Dodgson, called)** (Daresbury, England, 1832 – Guildford, England, 1898)

**48.** *Xie Kitchin en "Pénitence"* [Xie Kitchin as 'Penitence'], 1874. Wet collodion-on-glass negative, 21.7 x 16.5 cm. Gift of Gérard Lévy.
PHO 1989 1
Alexandra "Xie" Rhoda Kitchin (1864–1925) was the daughter of one of Lewis Carroll's colleagues at Christ Church College, the Rev. George William Kitchin. The biblical title that Carol gave his portrait was probably a reference to a sermon given by his friend Richard St John Tyrwhitt, published in 1859.

**49.** *Marion "Polly" et Florence "Flo" Terry*, [Marion (Polly) and Florence (Flo) Terry], 1865. Wet collodion-on-glass negative, 15.5 x 12.7 cm.
PHO 1988 10 17
A keen theatregoer and great admirer of the tragedienne Ellen Terry (1847–1928), Lewis Carroll stayed in the actress's family home at 92 Stanhope Street, London from 13 to 15 July

1865. During those three days he took a series of photographs of Ellen, who was then married to the painter George Frederick Watts; he also photographed her parents and her young brothers and sisters.

**Émile Zola** (Paris, France, 1840 – 1902)
Silver prints, each 22.5 x 16.2 cm.

**50.** *Denise de profil, à droite*, [Denise, right profile], ca. 1900.
PHO 1987 37 15

**51.** *Denise de face, tête appuyée sur la paume droite*, [Denise, Front View, Resting her Head on her Right Palm], c. 1900.
PHO 1985 75 12

Émile Zola discovered photography in 1888, a year before the birth of Denise, the elder of his two children born from his liaison with Jeanne Rozerot, but most of his photographs were taken between 1895 and 1902. Denise seems to have been willing to pose for him and helped her father find the best viewpoints.

**Pierre-Louis Pierson** (Hinckange, France, 1822 – Paris, 1913)

**52.** *La Normandie*, also called *La Comtesse de Castiglione accoudée, à l'éventail* [Normandy, or The Countess of Castiglione, Leaning on her Elbow, with a Fan], 1895. Albumen print from a glass negative, 14.5 x 10 cm.
PHO 1989 7 23

**53.** *Portrait de la comtesse de Castiglione, assise sur une table, le visage en partie coupé* [The Countess of Castiglione, Sitting on a Table, Face Partly Obscured], ca. 1865. Silver print (ca. 1900), 35 x 27 cm. Purchased by the National Photography Commission.
PHO 1993 8

Acclaimed as a great beauty in her time, the Countess of Castiglione (1837–99) kept an album of her life, posing regularly for Pierson. Although she was conforming to fashion in having her legs photographed, she dared show them naked without stockings and from a rather unflattering angle. At the end of her life, when she was poor, alone, and suffering from bouts of mental disturbance, she kept posing, trying to revive the past and parodying it at the same time.

**Léopold Reutlinger** (Callao, Peru, 1863 – Paris, 1937)

**54.** *Anna Held*, ca. 1900. Albumen print glued on card, 13.5 x 9.5 cm.
PHO 2001 11 33

**55.** *La Belle Otero* [The Beautiful Miss Otero], 1893. Albumen print, retouched with ink, glued on card, 13.5 x 9.5 cm. Gift of Jacques-Paul Dauriac through the Friends of the Musée d'Orsay.
PHO 2001 11 56

About 1850, Charles Reutlinger opened a studio in Paris which was taken over by his brother Émile in 1880, who was joined by his son Léopold in

1883. In 1890, Léopold married the sister of the actress Cécile Sorel and took over the management of the studio. Among the many personalities from the theatre world who flocked to the studio, renamed "La Photographie d'Art", was the music-hall actress Anna Held (1873–1918), who became famous in the United States through the *Ziegfeld Follies* and *La Belle Otero* (Caroline Augusta Carasson Otero, 1869–1965). Apart from her renown on stage, she kept the public entertained with her love affairs.

**Edgar Degas** (Paris, 1834 – 1917)

**56.** *Autoportrait avec Yvonne et Christine Lerolle* [Self-portrait with Yvonne and Christine Lerolle], ca. 1895. Silver print from a glass negative, enlarged by Tasset, 35.5 x 29 cm. Purchased with the aid of the National Photography Commission. PHO 1998 9

**57.** *Portrait au miroir d'Henry Lerolle et de ses deux filles, Yvonne et Christine* [Mirror Portrait of Henry Lerolle and his Daughters, Yvonne and Christine], ca. 1895. Silver print from a glass negative, enlarged by Tasset, 29 x 36.2 cm. PHO 2004 4

Christine Lerolle (1879–1941) and her sister Yvonne (1877–1944), the daughters of Degas's friend, the painter Henry Lerolle (1848–1929), married Louis and Eugène Rouart respectively. On several occasions, they agreed to endure the long sittings imposed by their director, who was described by his models as fussy if not tyrannical!

**58. Edward Steichen** (Bivange, Luxembourg, 1879 – West Redding, Connecticut, 1973), *Bartholomé*, 1901. Photoengraving, 21 x 15.2 cm. *Camera Work*, no. 2, pl. V, April 1903. Gift of Minda de Gunzburg through the Friends of the Musée d'Orsay. PHO 1981 22 13

In 1901, while he was in Paris, Steichen took a series of photographs of artists he admired. Here he photographed the sculptor Paul-Albert Bartholomé (1848–1928) in front of one of his works, *The Pam Family Monument* (Montmartre Cemetery).

**59. Adolphe de Meyer** (Paris, 1868 – Hollywood, California, 1946), *La Danseuse Ruth Saint Denis* [The Dancer Ruth Saint Denis], ca. 1907. Platinum print, 25.1 x 20.1 cm. PHO 1984 67

The Musee d'Orsay has an album of thirty photographs by Adolphe de Meyer of Nijinsky performing in Debussy's *The Afternoon of a Faun*. The photographer's interest in dancing was confirmed with this photograph of Ruth Saint Denis (1878–1968), an American dancer, teacher and choreographer.

**Paul Strand** (New York, 1890 – Orgeval, France, 1976)

**60.** *Photograph – New York*, 1917. Photoengraving, 22 x 16.3 cm. PHO 1981 35 1

**61**. *Photograph – New York*, 1917. Photoengraving, 15.9 x 17.2 cm. PHO 1981 35 5

Illustrations from *Camera Work*, no. 49/50, pl. I and IV, 1917. Gift of Minda de Gunzburg through the Friends of the Musée d'Orsay.

"Photography is only a new road from a different direction but moving toward the common goal, which is Life" (Paul Strand, "Photography", in *Camera Work*, no. 49/50, 1917, reprinted from *Seven Arts*).

**62. Alfred Stieglitz** (Hoboken, New Jersey, 1864 – New York, 1946), *Portrait de Man Ray*, [Portrait of Man Ray], c. 1915. Silver print from a glass negative, 27 x 19.7 cm.
PHO 2005 7

"One day when I was the only visitor in the gallery ["291"] he set up an old camera on a wobbly tripod and asked me to pose against a wall [...]. He said the exposure time would be quite long but that I was to keep looking at the lens. I could blink my eyes because that would not make any difference and would not be seen in the print. He produced a hoop covered with cotton cloth, uncovered his lens and began to circle it above my head. He moved like a dancer, peering at me closely. That lasted for about ten seconds" (Man Ray, *Autoportrait*, Robert Laffont, 1963).

Françoise Heilbrun

# Selected Bibliography

Apraxine Pierre, Demange Xavier and Heilbrun Françoise. *La Comtesse de Castiglione par elle-même*. Exhib. cat., Musée d'Orsay, 12 Oct. 1999–23 Jan. 2000. Paris: Réunion des musées nationaux, 1999.

Aubenas Sylvie and Biroleau Anne (ed.). *Portraits / Visages*. Exhib. cat., Bibliothèque nationale de France, 27 Oct. 2003–11 Jan. 2004. Paris: Bibliothèque nationale de France / Gallimard, 2003.

Bajac Quentin and Font-Réaulx Dominique de (ed.). *Le Daguerréotype français, un objet photographique*. Exhib. cat., Musée d'Orsay, 13 May–17 Aug. 2003. Paris: Réunion des musées nationaux, 2003.

Cox Julian and Ford Colin (ed.). *Julia Margaret Cameron. The Complete Photographs*. London: Thames and Hudson, 2003.

Daniel Malcolm (ed.). *Edgar Degas, Photographer*. New York: The Metropolitan Museum, 1998, (*Edgar Degas photographe*, French transl. by William O. Desmond. Paris: Bibliothèque nationale de France, 1999).

Dodier Virginia and Heilbrun Françoise. *Lady Hawarden photographe victorien*. "Les Dossiers du musée d'Orsay". Paris: Réunion des musées nationaux, 1990.

Greenough Sarah and Strand Paul. *Paul Strand: An American Vision*. Washington, D.ca.: National Gallery of Art and Aperture Foundation, 1990.

Heilbrun Françoise and Molinari Danielle (ed.). *Victor Hugo, photographies de l'exil, en collaboration avec le soleil*. Exhib. cat., 27 Oct. 1998–24 Jan. 1999. Paris: Musée d'Orsay / Maison de Victor Hugo / Réunion des musées nationaux, 1998.

Heilbrun Françoise, Morris Hambourg Maria, Néagu Philippe and Aubenas Sylvie. *Nadar, les années créatrices, 1854–1860*. Exhib. cat., Musée d'Orsay, 7 June–11 Sept. 1994. Paris: Réunion des musées nationaux, 1994.

Heilbrun Françoise and Néagu Philippe. *Portraits d'artistes*. "Les Dossiers du musée d'Orsay". Paris: Réunion des musées nationaux, 1986.

Héran Emmanuelle and Bolloch Joëlle. *Le Dernier Portrait*. Exhib. cat., Musée d'Orsay, 5 Mar.–26 May 2002. Paris: Réunion des musées nationaux, 2002.

McCauley Anne. *Industrial Madness: Commercial Photography in Paris, 1848–1871*. London, New Haven: Yale University Press, 1994.

McCauley Ann, Bocard Hélène, Morand Sylvain, Poivert Michel and Rapetti Rodolphe. *Olympe Aguado photographe*. Strasbourg: Musées de Strasbourg, 1997.

Mondenard Anne de and Pultz John. *Le Corps photographié*. Paris: Flammarion, 1995.

Naef Weston (ed.). *Fifty Pioneers of Modern Photography, the Collection of Alfred Stieglitz*. New York: The Metropolitan Museum of Art, 1978.

Nickel Douglas. *Dreaming in Pictures, the Photography of Lewis Carroll*. New Haven: Yale University Press, 2002.

Romer Grant B. and Wallis Brian. *Young America, the Daguerreotypes of Southworth and Hawes*. New York: George Eastman House, International Center of Photography, 2005.

Rouillé André and Marbot Bernard. *Le Corps et son image: photographies du xixe siècle*. Paris: Contrejour, 1986.

Sagne Jean. *L'Atelier du photographe*. Paris: Presses de la Renaissance, 1984.

Smith Joel. *Edward Steichen, the Early Years*. Princeton, New York: Princeton University Press, The Metropolitan Museum of Art, 1999.

Wakeling Edward. *Lewis Carroll's Diaries: The Private Journals of Charles Lutwidge Dodgson*. Luton: Lewis Carroll Society, 1993.

Weaver Mike. *Julia Margaret Cameron 1815–1879*. Southampton: John Hansard Gallery, 1984.

Wey Francis, "Théorie du portrait I et II" *La Lumière*, 27 April 1851, 4 May 1851, pp. 46–51.

Plates

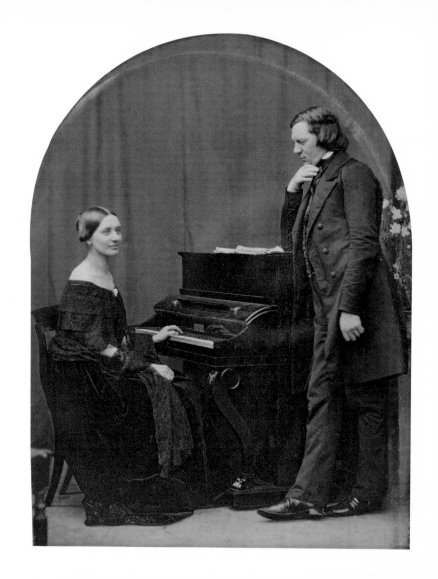

**1. Anonyme**
*Robert et Clara Schumann*
Ca. 1850

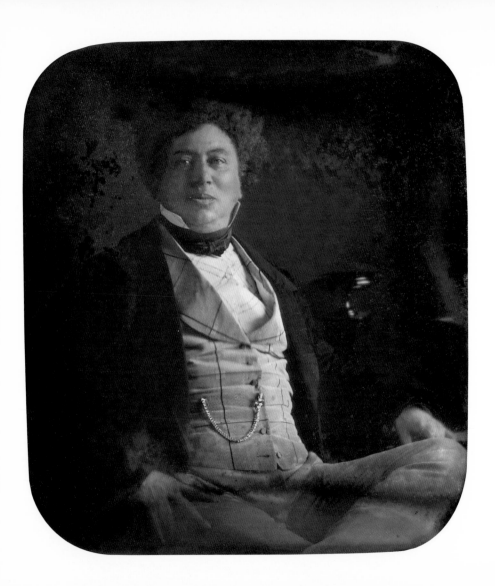

**2. Alexis Louis Charles Gouin**
*Portrait d'Alexandre Dumas*
Ca. 1851

**3. François-Victor Hugo**
*Victor Hugo accoudé à une barrière, devant la façade arrière de Marine-Terrace*
1853

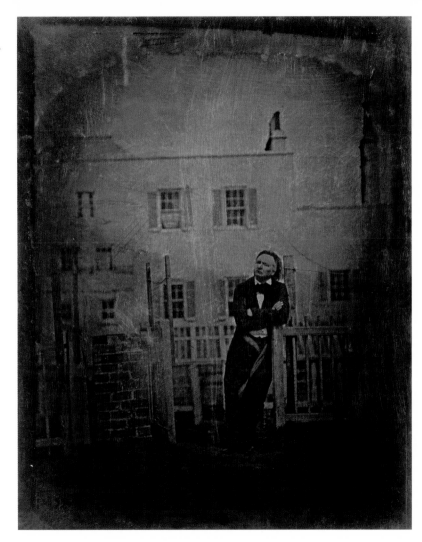

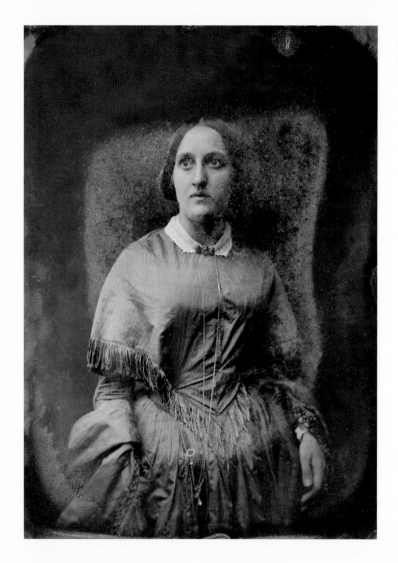

**4. Southworth & Hawes**
*Sarah Jane Clarke*
Ca. 1850

**5. Louis Adolphe Humbert de Molard**
*Portrait de Louis Dodier, la joue appuyée sur la main*
Ca. 1845

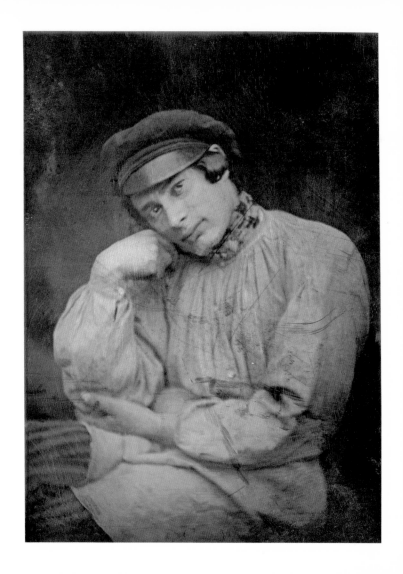

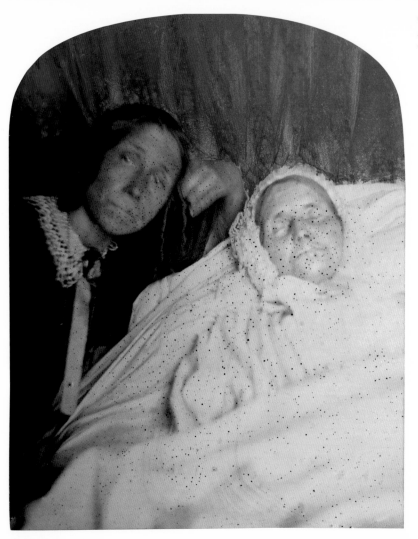

**6. Anonyme**
*Portrait après décès*
Ca. 1860

**7. Anonyme**
*Famille au chevet d'une
jeune femme décédée*
Ca. 1850

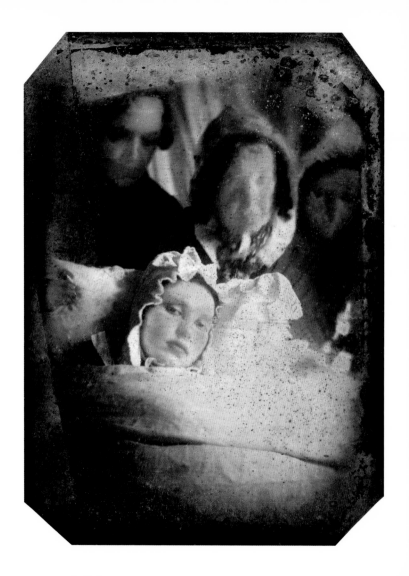

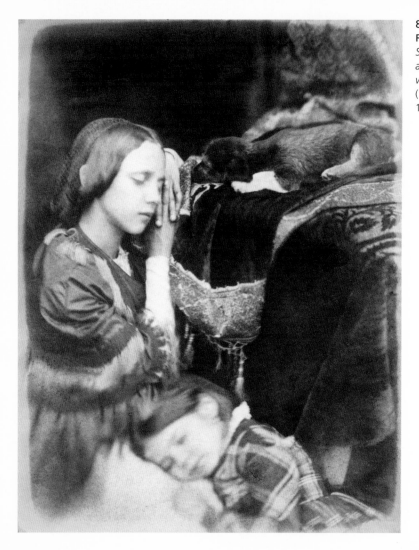

8. **David Octavius Hill,
Robert Adamson**
*Sophia Finlay
and Harriet Farnie,
with « Brownie »*
(*The Sleepers*)
1845

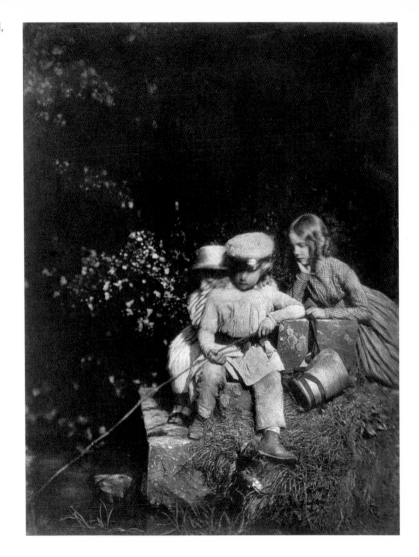

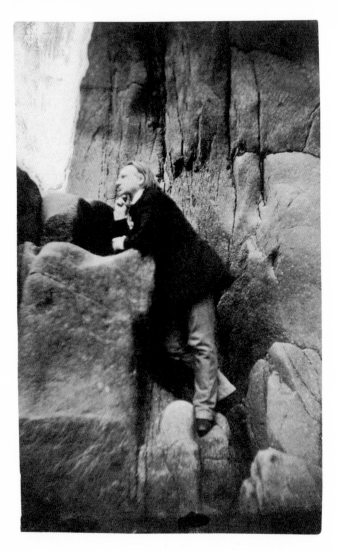

**10. Charles Hugo**
*Victor Hugo dans le rocher des Proscrits*
Ca. 1853

**11. Charles Hugo**
*Victor Hugo sur le rocher des Proscrits*
Ca. 1853

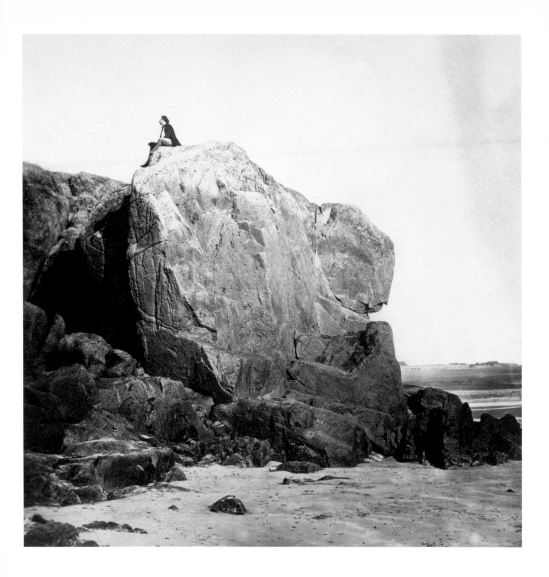

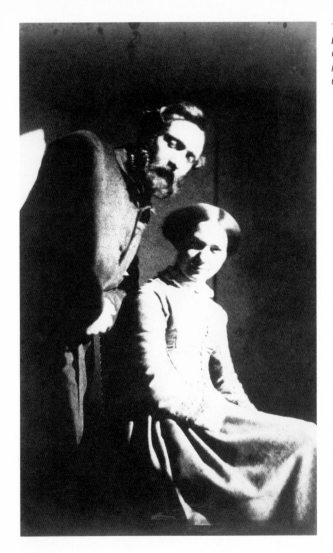

**12. Louis Robert**
*La fille du photographe,
Caroline, avec son époux,
le peintre Émile Van Marcke*
Ca. 1852

**13. Louis Robert**
*La fille du photographe,*
*Caroline, avec son*
*époux, le peintre*
*Émile Van Marcke,*
*et Églée Marie Robert,*
*dans le jardin de la*
*manufacture de Sèvres*
Ca. 1852

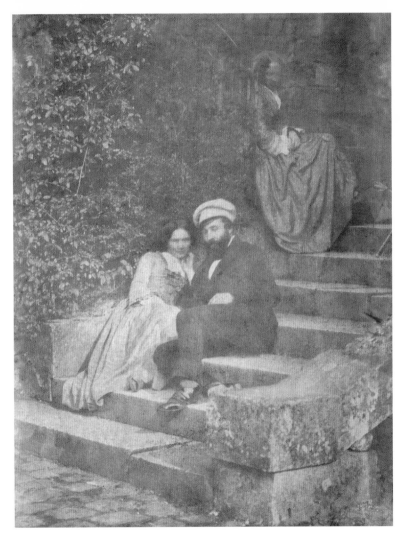

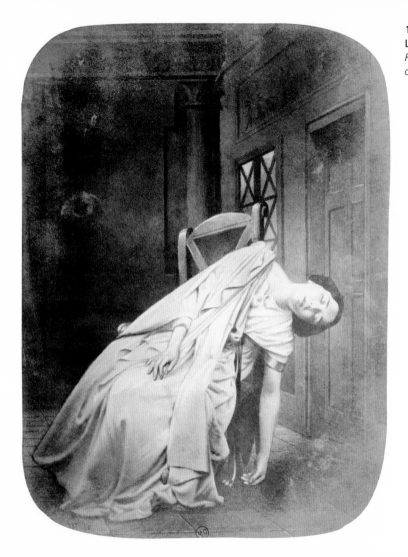

**14. Henri de La Blanchère**
*Rachel dans le rôle de « Camille »*

**15. Charles Nègre**
*Portrait de Rachel
à Auteuil*
1853

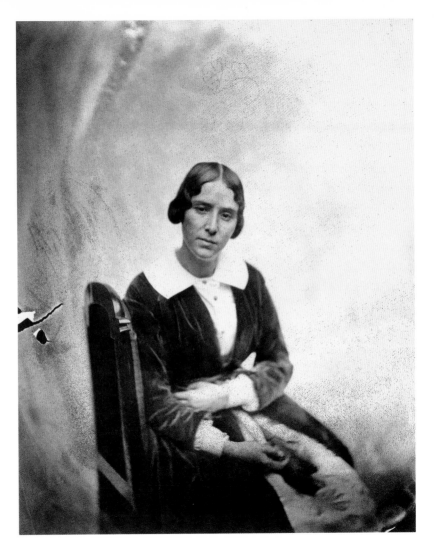

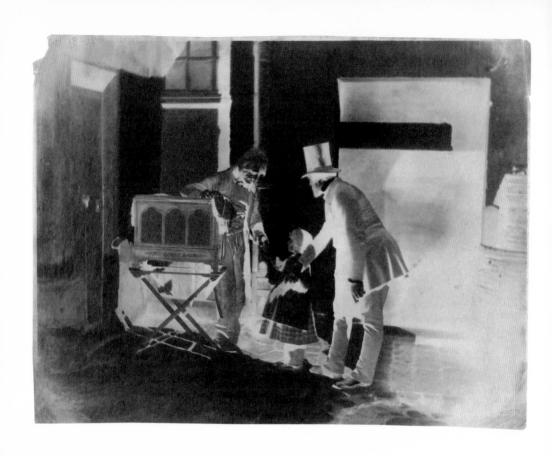

**16. Charles Nègre**
*Henri Le Secq et une petite fille*
*faisant l'aumône au joueur d'orgue*
Ca. 1853

**17. Charles Nègre**
*Le Stryge*
1853

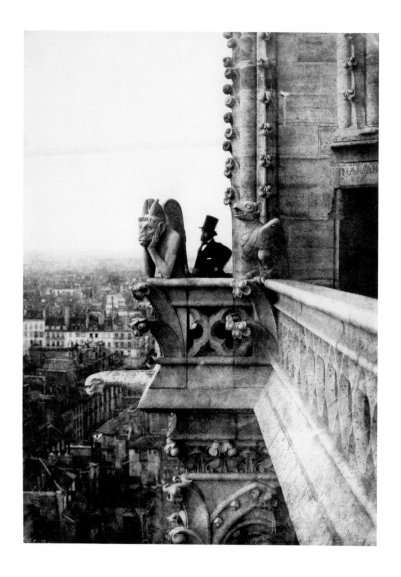

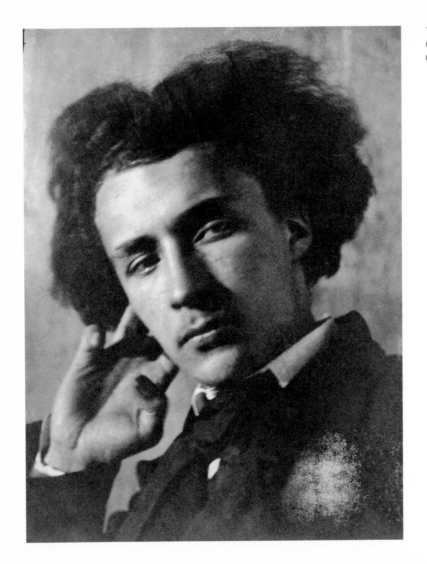

**18. Charles Marville**
*Charles Delahaye*
Ca. 1852

**19. Charles Marville**
*Charles Delahaye*
*debout sur un balcon,*
*rue Saint-Dominique (?)*
Ca. 1852

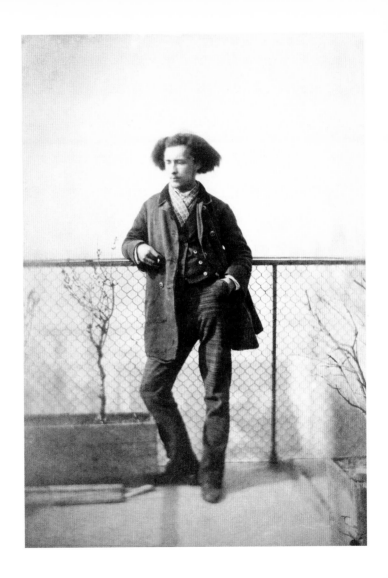

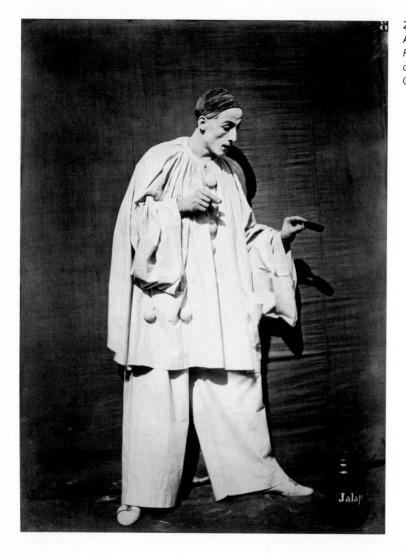

**20. Félix Nadar,
Adrien Tournachon**
*Pierrot au pot
de médecine*
Ca. 1854

21. Félix Nadar,
Adrien Tournachon
*Pierrot souffrant*
Ca. 1854

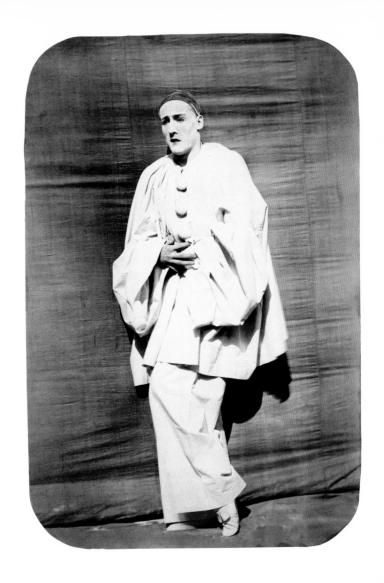

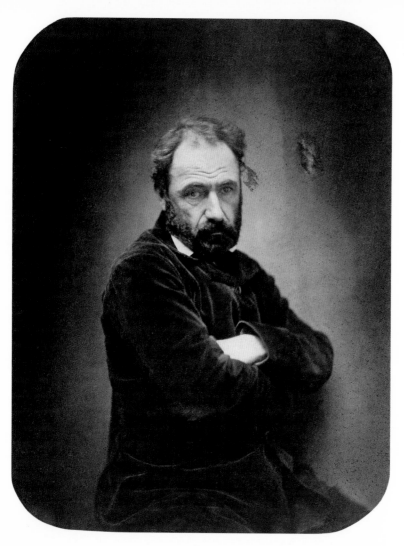

**23. Félix Nadar**
*Portrait de Charles Baudelaire*
Ca. 1856

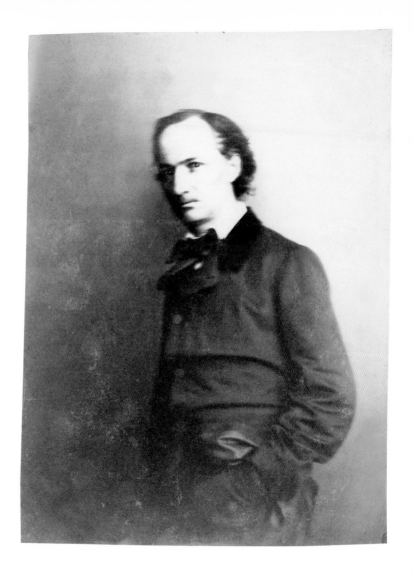

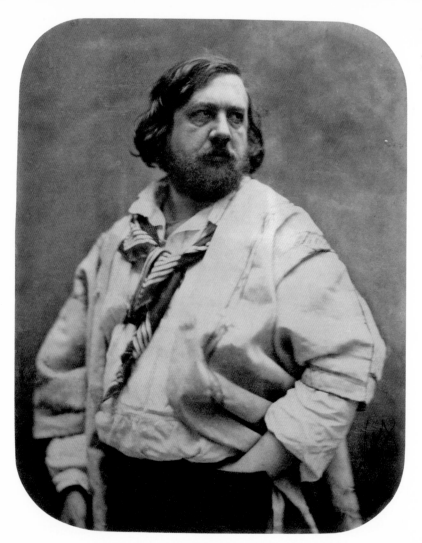

**24. Félix Nadar**
*Théophile Gautier
à la blouse blanche*
Ca. 1854

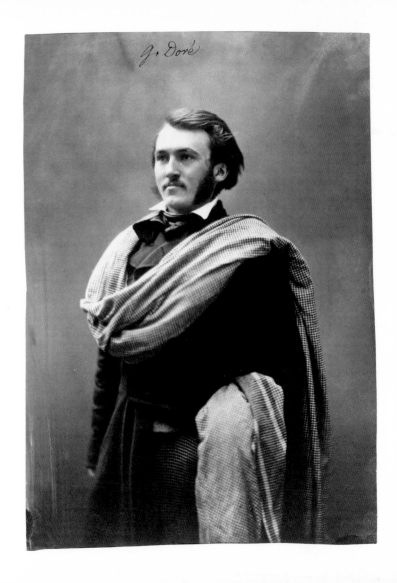

**25. Félix Nadar**
*Gustave Doré au drapé*
Ca. 1856

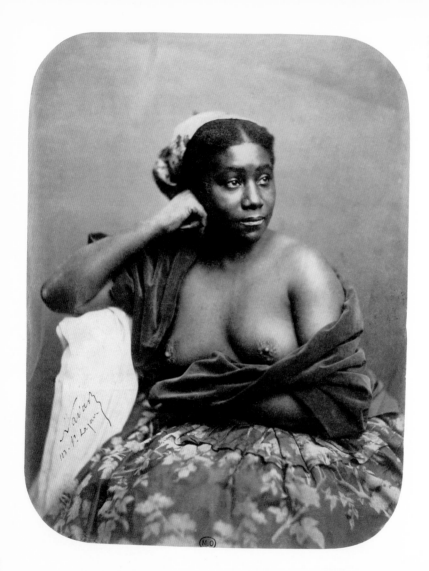

**26. Félix Nadar**
*Maria l'Antillaise*
Ca. 1856

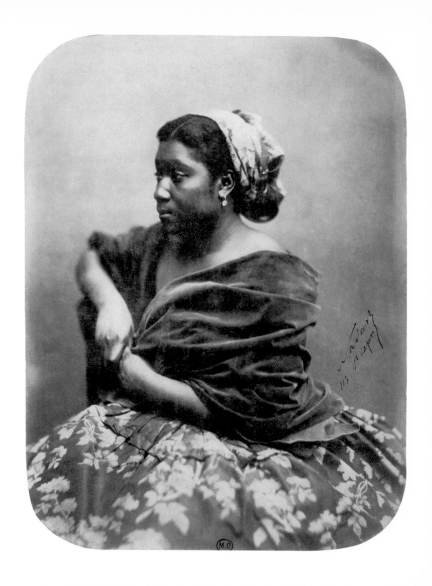

**27. Félix Nadar**
*Maria l'Antillaise*
Ca. 1856

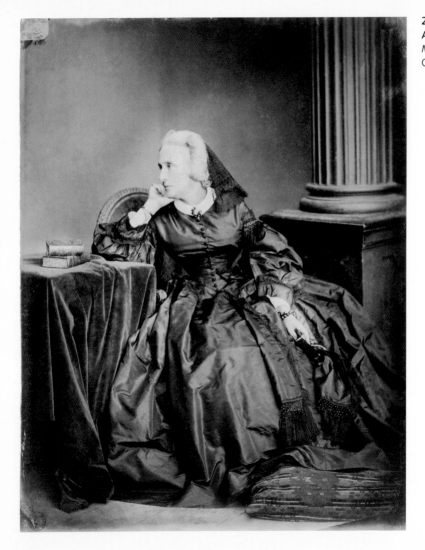

**28. Antoine-Samuel Adam-Salomon**
*Marie d'Agoult*
Ca. 1861

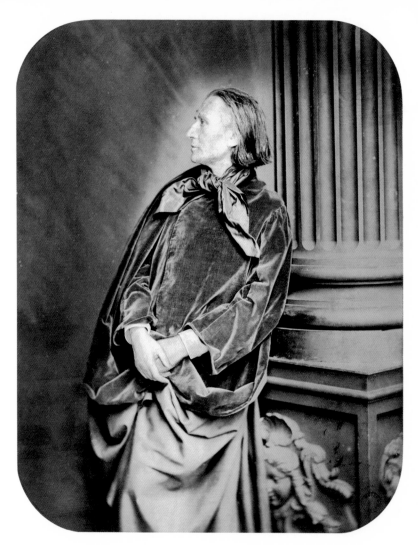

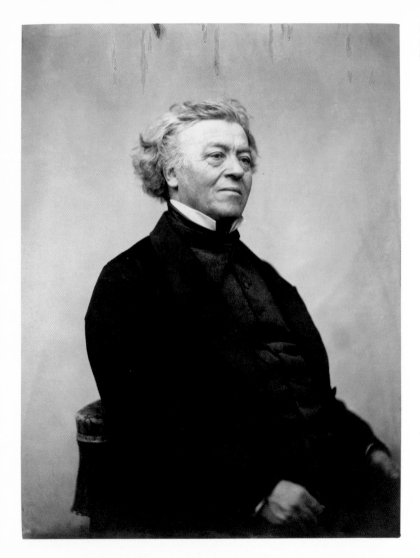

**30. Pierre Petit**
*Camille Corot*
Ca. 1860

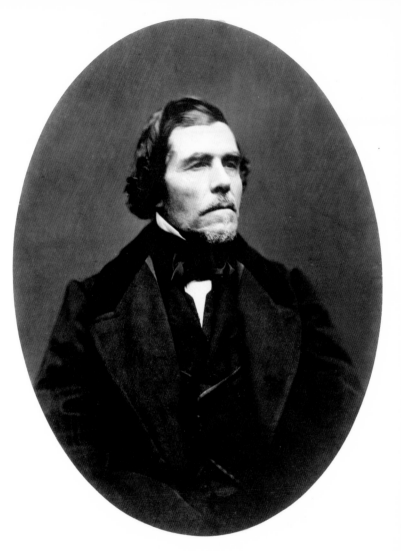

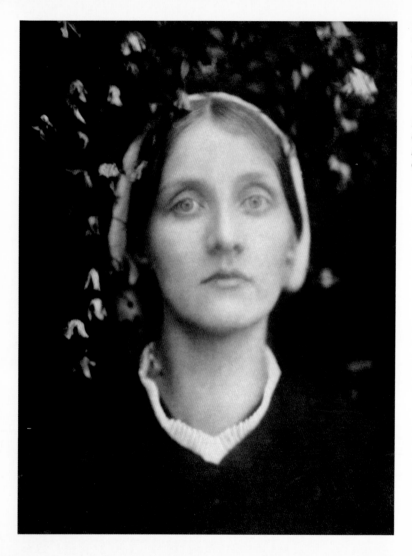

**32. Julia Margaret Cameron**
*Madame Herbert Duckworth, mère de Virginia Woolf*
1872

**33. Julia Margaret Cameron**
*Maud*
Ca. 1875

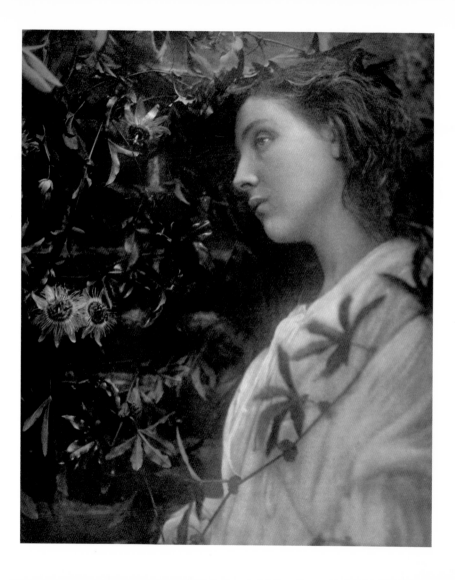

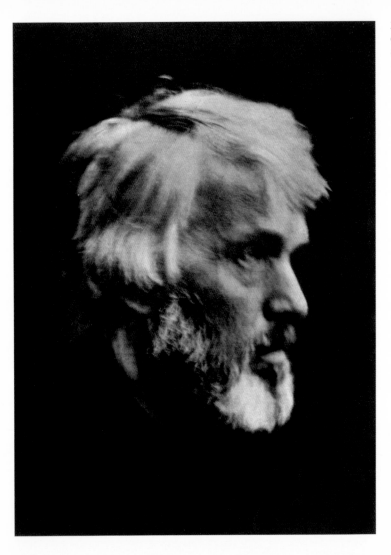

**34. Julia Margaret Cameron**
*Carlyle*
1867

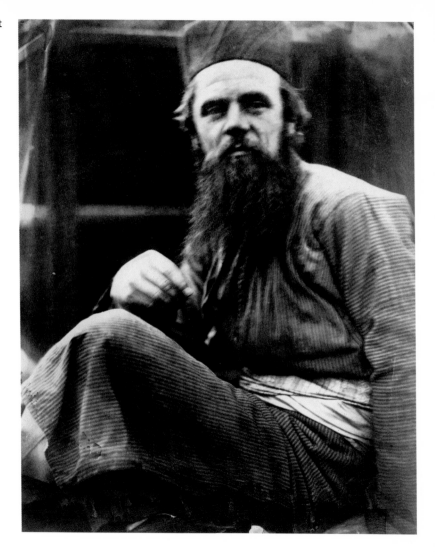

**35. Julia Margaret Cameron**
*William Holman Hunt*
1864

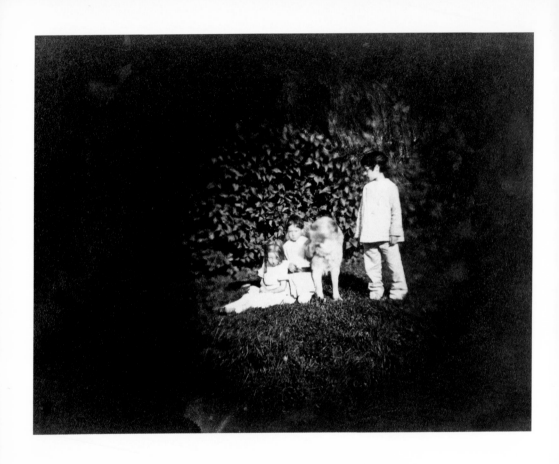

**36. Charles Nègre**
*Trois enfants et un chien dans un parc*
Ca. 1853

**37. Julia Margaret Cameron**
*Group*
Ca. 1870

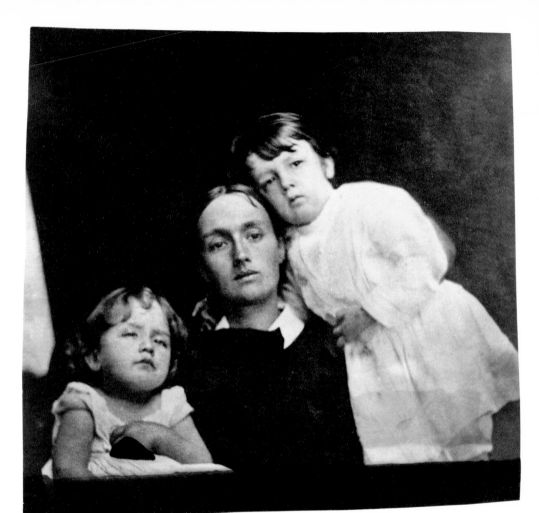

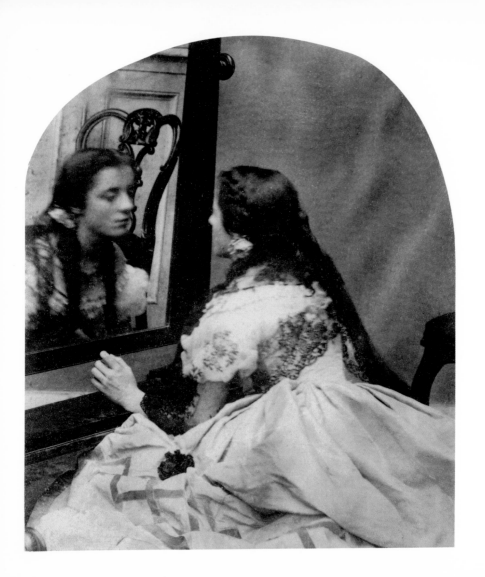

**38. Lady Clementina Hawarden**
*Isabella Grace Maude se regardant dans un miroir*
1861

**39. Jean-Baptiste Frénet**
*Les Deux Sœurs*
Ca. 1855

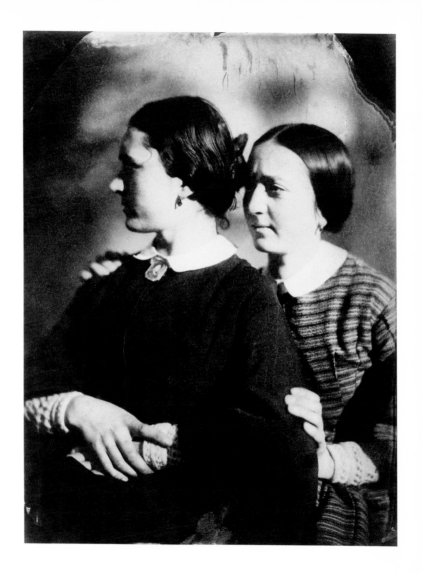

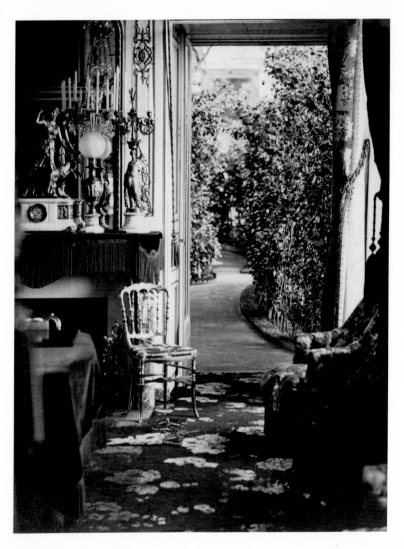

**40. Olympe Aguado (comte)**
*Château de Sivry, vue intérieure d'un salon*
Ca. 1856

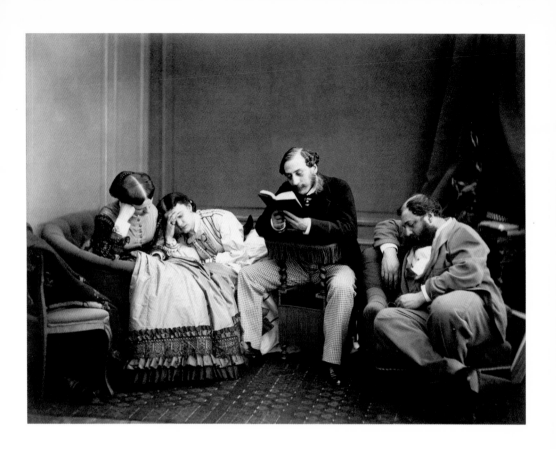

**41. Olympe Aguado (comte)**
*La Lecture*
Ca. 1862

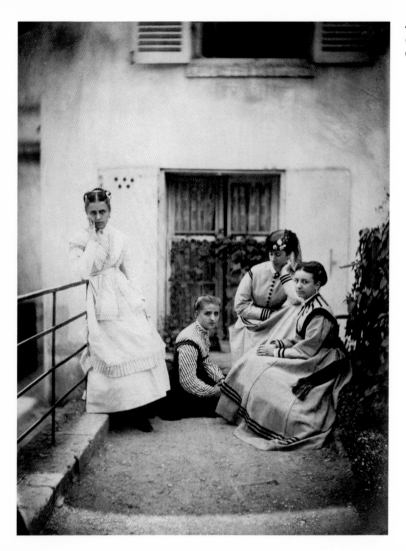

**42. Achille Bonnuit**
*Groupe de femmes*
Ca. 1870

**43. Achille Bonnuit**
*Le Repos*
Ca. 1860

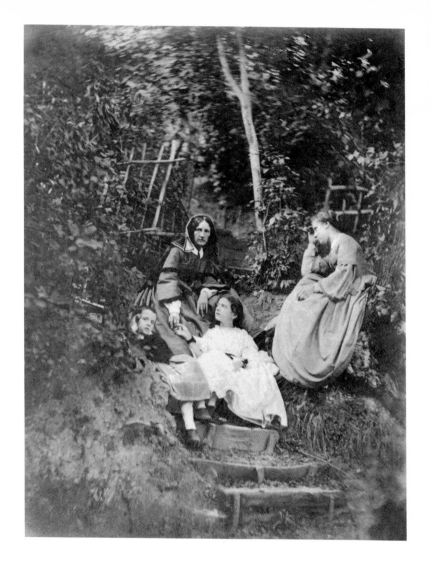

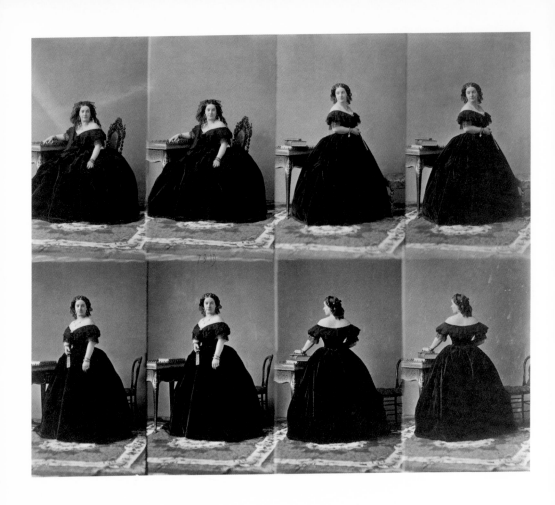

**44. André-Adolphe-Eugène Disdéri**
*Marquise de Jalar en pied, en huit poses*
1860

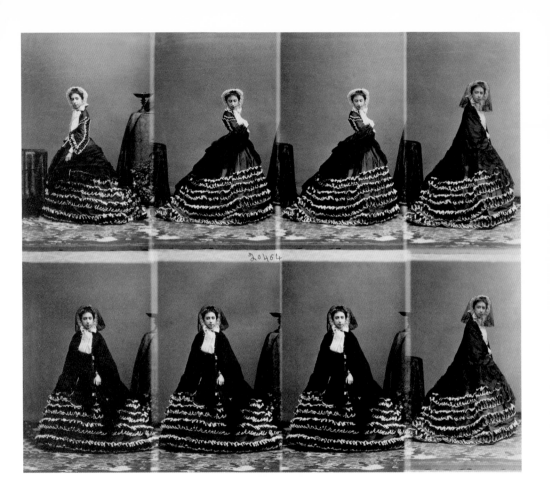

**45. André-Adolphe-Eugène Disdéri**
*Princesse de Polignac, en huit poses*
1859

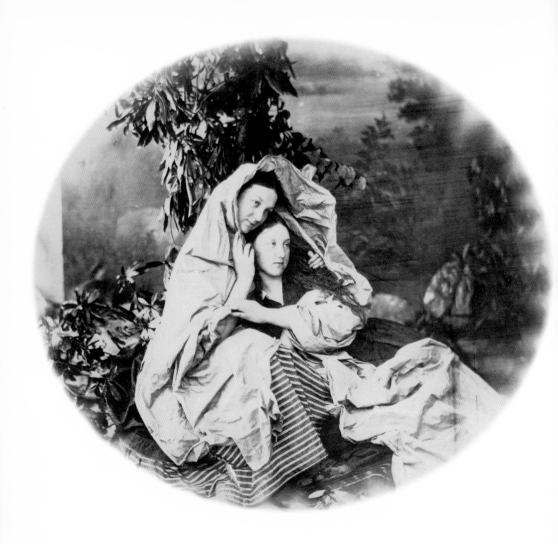

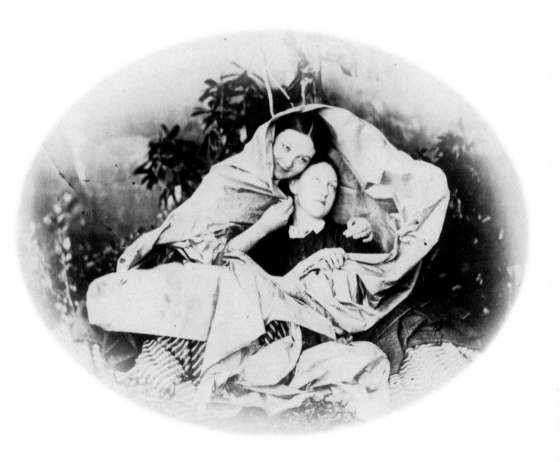

**46–47. Marie Jane Matheson (Lady)**
*Adelaïde et Elizabeth Denys*
*enveloppées dans un châle*
Ca. 1860

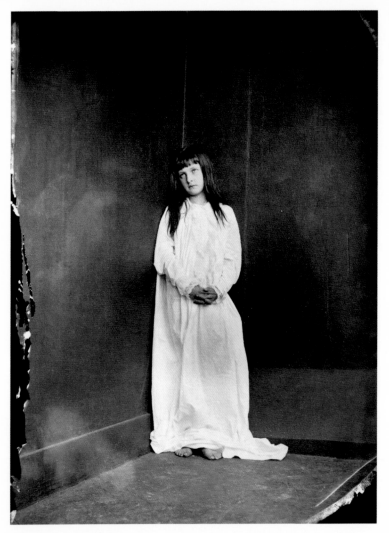

**48. Lewis Carroll (Charles Lutwidge Dodgson)**
*Xie Kitchin en « Pénitence »*
1874

**49. Lewis Carroll
(Charles Lutwidge
Dodgson)**
*Marion «Polly»
et Florence
«Flo» Terry*
1865

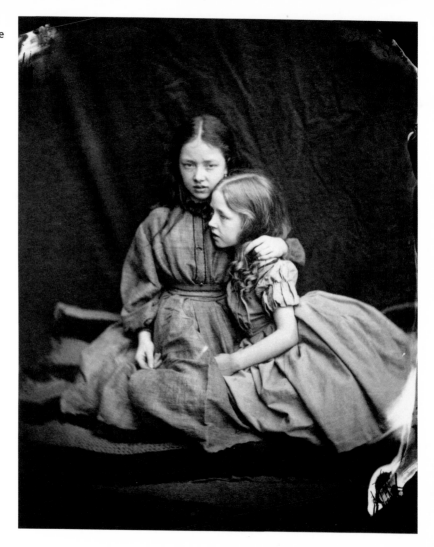

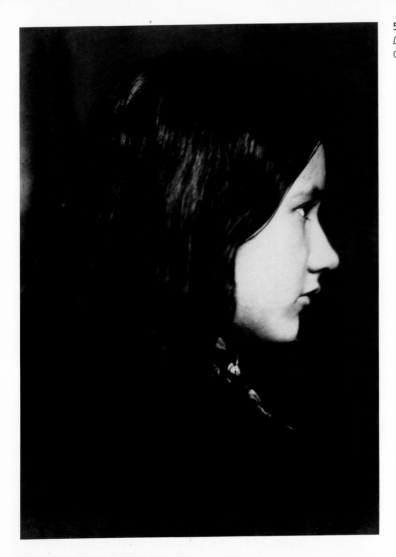

**50. Émile Zola**
*Denise de profil, à droite*
Ca. 1900

**51. Émile Zola**
*Denise de face,*
*tête appuyée sur*
*la paume droite*
Ca. 1900

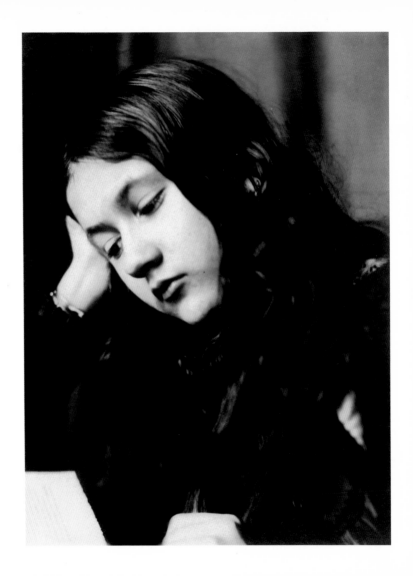

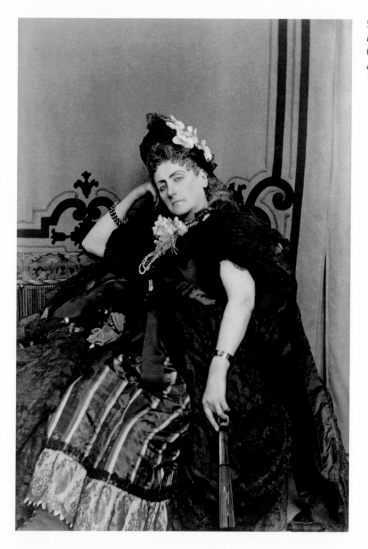

**52. Pierre-Louis Pierson**
*La Normandie*
(*La Comtesse de Castiglione
accoudée, à l'éventail*)
1895

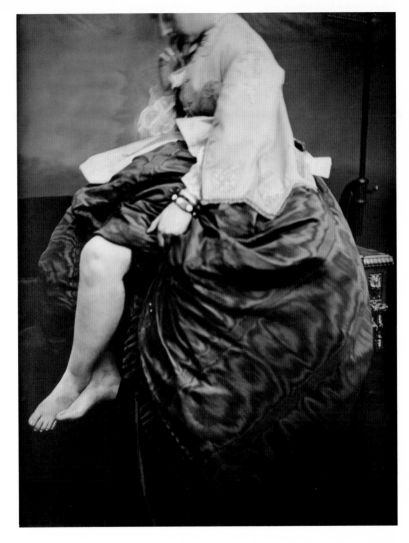

**53. Pierre-Louis Pierson**
*Portrait de la comtesse de Castiglione, assise sur une table, le visage en partie coupé*
Ca. 1865

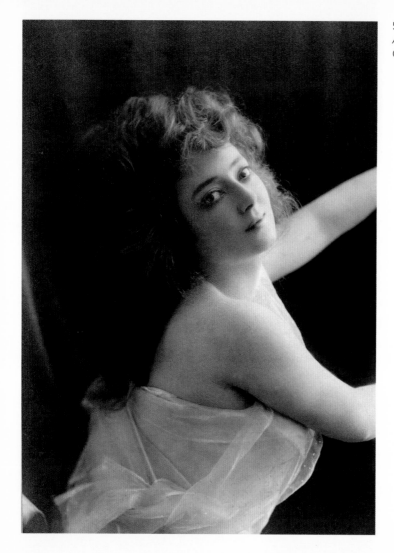

**54. Léopold Reutlinger**
*Anna Held*
Ca. 1900

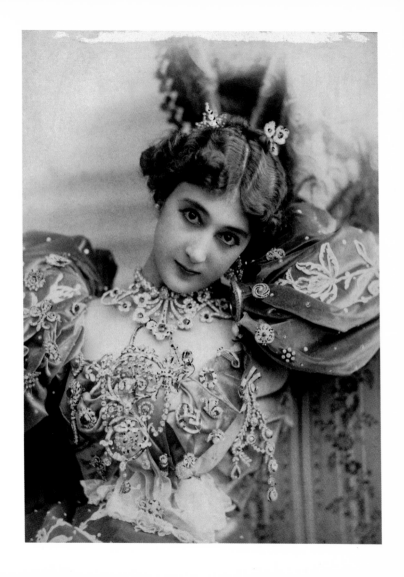

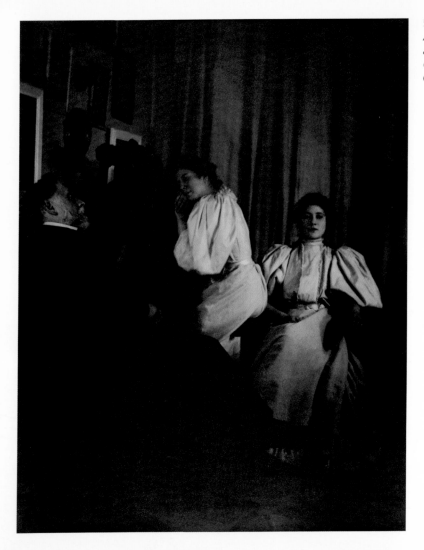

**56. Edgar Degas**
*Autoportrait
avec Yvonne et
Christine Lerolle*
Ca. 1895

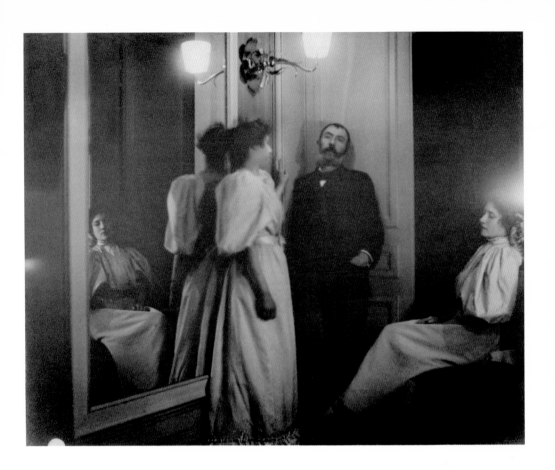

**57. Edgar Degas**
*Portrait au miroir d'Henry Lerolle et
de ses deux filles, Yvonne et Christine*
Ca. 1895

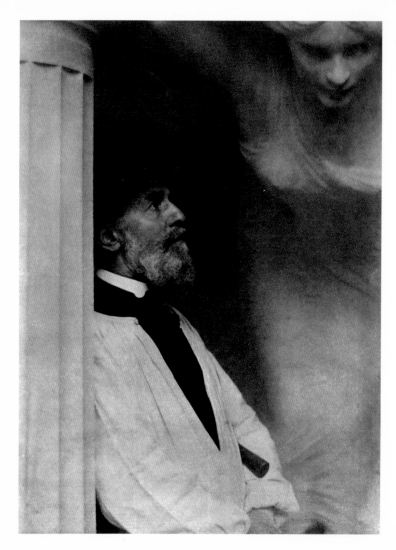

**58. Edward Steichen**
*Bartholomé*
1901

**59. Adolphe
de Meyer**
*La Danseuse
Ruth Saint Denis*
Ca. 1907

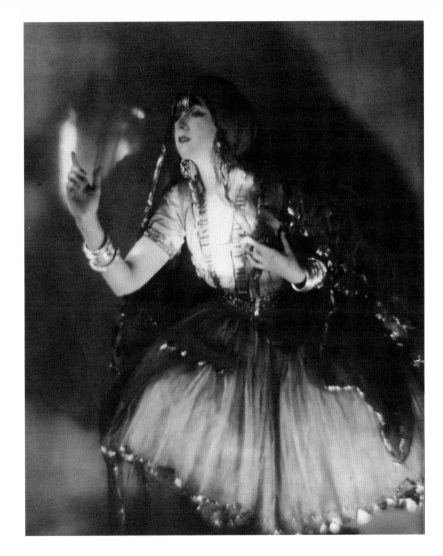

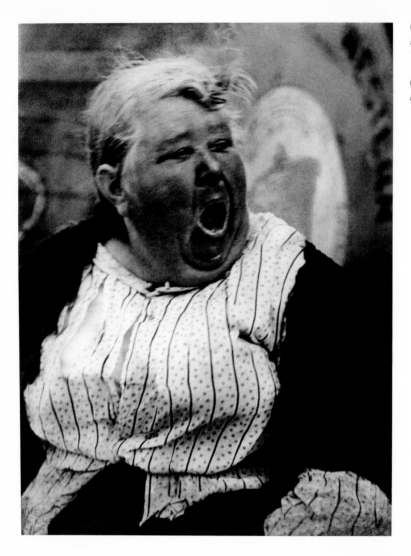

**60. Paul Strand**
*Photograph – New York*
1917

**61. Paul Strand**
*Photograph – New York*
1917

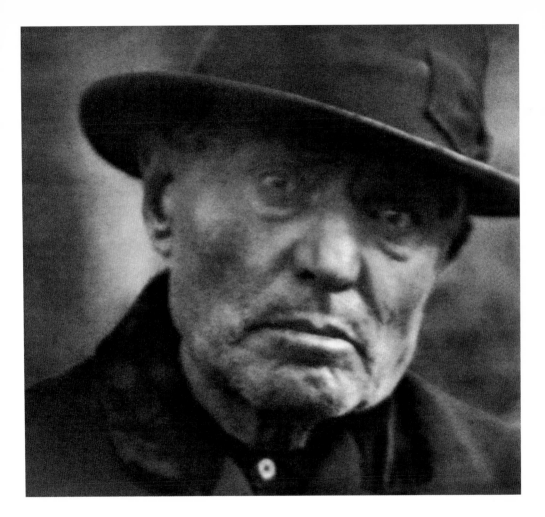

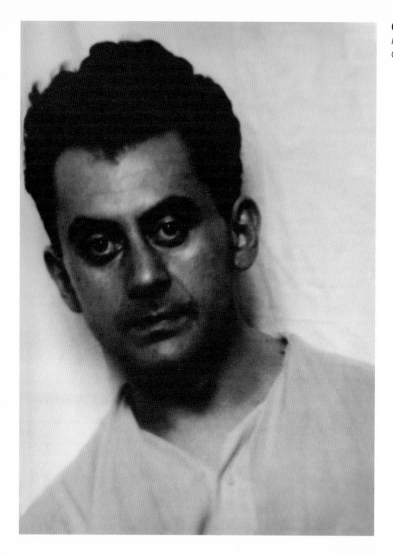

**62. Alfred Stieglitz**
*Portrait de Man Ray*
Ca. 1915